AN AMERICAN FIELD GUIDE

AN AMERICAN FIELD GUIDE ✳ VOLUME 1

Common Ground

PHOTOGRAPHS, SEQUENCING, AND TEXT BY

Gregory Conniff

YALE UNIVERSITY PRESS NEW HAVEN AND LONDON

Designed by Christopher Harris
and set in Meridian type by
Eastern Typesetting Company.
Printed in the United States of America by
Rembrandt Press, Inc., Milford, Connecticut.

Library of Congress Cataloging in Publication Data

Conniff, Gregory, 1944–
 An American field guide.

 Contents: v. 1. Common ground.
 1. United States—Description and travel—1981–
—Views. 2. Photography, Artistic. I. Title.
E169.04.C66 1985 779'.9973 84–40669
ISBN 0–300–03407–5 (v. 1)

The paper in this book meets the guidelines for permanence
and durability of the Committee on Production Guidelines
for Book Longevity of the Council on Library Resources.

10 9 8 7 6 5 4 3 2 1

FOR DOROTHY AND RUTH

Our overwhelming formal education deals in words, mathematical figures, and methods of rational thought, not in images. This may be a form of conspiracy that promises artificial blindness. It certainly is that to a learning child. It is this very blindness that photography attacks, blindness that is ignorance of real seeing and is perversion of seeing. It is reality that photography reaches toward. The blind are not totally blind. Reality is not totally real.

—Walker Evans

There is no excellent beauty that hath not some strangeness in the proportion.

—Francis Bacon

Contents

Introduction

The subject of *An American Field Guide* is physical America, the places of daily life. I approach it in the belief that American space, American light, the things of this country come together to form a voice that shapes how we think and feel, much as our parents' voices shaped us in childhood. Whatever we think of this voice, however we react to it, we can no more escape its influence than we can eradicate our childhood. The field guide is about other matters as well—photography, landscape, the eye, the mind, art, and work—but whatever ideas we may map on its surface, it has as its structure the specific and tangible things that surround us, whether we notice them or not.

In my work as a photographer I have learned to make images of my everyday landscape that help me see and value elements of it often invisible in their commonness. I am organizing these photographs and some discursive essays into a series of four books that are guides to anywhere although they are specifically about America as I see it. The series is really about bringing the eye to a state of health and about testing what we see and know against ourselves in the world rather than against reports of that world.

Sometimes when I step out my front door I wonder where I am. I ask myself how I got there and where else I might be. At other times I will be in a place entirely new to me and feel that I've been there before. And frequently enough to be noticeable I find myself in a blank stare, oblivious, somewhere else. In these moments I experience a sense of dislocation that I think most of us would recognize. It may be a difference between us, though, that I delight in this dislocation and have pursued it. I like it, I think, because I enjoy traveling and feel that to be dislocated like this is not to be lost, not to feel displaced, but simply to occupy two places at the same time.

When I go on the road my style of traveling is to maintain this spirit of dislocation. I wander about following my eye, stumbling across things and getting into situations. Sometimes I use maps, but rarely will I consult a guidebook. Maps offer choices from a world of possibilities while guidebooks offer certainties that inhibit my ability to experience new facts with an open mind and from my point of view. Listen to travelers' tales and you will find that the treasured moments are the unexpected ones, the ones filled with personal discovery, not those that confirm things long known.

If the pleasure of travel is discovery, then the value of travel lies in learning to

see as a traveler does, to see things new. I believe that this way of seeing is the natural state of the healthy eye. I also believe that we can see this way anywhere. Besides encouraging us to recognize that everywhere is elsewhere to someone from out of town, travel ought to help us break habitual ways of seeing things so that we can come home again alert to the pleasures and mysteries that lurk in the most familiar places.

To my mind, guidebooks choose to avoid most of what is out there. They set themselves to the easy task of drawing attention to distinguishable phenomena and ignore the connective tissue that holds the world together. They reinforce the notion that what is worth pursuing is somehow never where we live. On the other hand, I am drawn to places that have no one overwhelming point of interest, but which seem to glow from generations of human presence. America is filled with such places. You probably live in one.

What I have called *Common Ground* is the space around American homes. It is the yards we knew intimately as children, and the yards from which we leave and to which we return in the dailiness of our adult lives. It is a primary place, a personal landscape. It is home ground. At the same time it is open to the view of others. It is common ground. This place acquires character with age and carries in its fences, hedges, and gardens-gone-to-ruin, memories of former dwellers and their sense of space. It is a landscape we share across time, across ownership, and across the country—if only in our mind's eye.

This book, like this landscape, is a point of departure and a place of return for the three books to follow. The second and third volumes of the field guide will take as their respective subjects American workplaces and water in America. I view these subjects very broadly. My intention is not to confirm anyone's idea of what these subjects are but to exercise the notions that there is more than one way to look at anything and that maintaining multiple viewpoints does not require us to transcend the direct appearance of the facts at hand.

The human presence in the first three books will have been an implied one; in the final volume of the field guide we will see people for the first time. A composer friend describes his process of building a piece of music as one of leaving a home place, moving out from it until the tension forces him to pause and see where he is in relation to that home place, and then reaching for an elegant means of return. That describes equally well the structure I intend for the field guide. The last book will bring it all home again, redefining everything that has come before, because there is no end to human surprise. The finished project will reveal an America that I see, framed by the interconnection of people, things, and land—family, the knowledge of specific objects, and the community of being that comes from sharing a particular place.

Of course, all this—choice of subject, thematic organization, the look of the images—is from my point of view. As my point of view is the backbone of this work and as the concept of "point of view" is at the heart of the essay to follow, I want to sketch quickly some of the terrain that governs how I look at things. I am an American. Born and raised in New Jersey, educated in New York and Virginia, living now in Wisconsin. I have worked as a truck driver, a lecturer, a carpenter, an artist's apprentice, an electronics manufacturer, and a lawyer. Moving back and forth between the realm of objects and the realm of words I found that I think better around things I can touch. I seek out things made with appetite, things that reach to others, that are warmed, no matter how shocking might be their gesture, by the love of being human. Above all, I am interested in how and why America looks as it does and whether it appears the same to you as it does to me.

An artist, to me, is someone who adds to the possible ways of knowing the world, whose point of view increases the potential of our moments. My desire as an artist is to be at least as useful and involved a part of society now as I was behind the wheel of a truck or in front of a jury. That is one reason I call this project a "field guide"—to place it plain before you as a tool. I agree with the poet-essayist-farmer Wendell Berry, who wrote, "A man who has created a fact or an idea has not completed his responsibility to it until he sees it is well used in the world."

Facts are everywhere. Facts come first. Their usefulness becomes visible as we push them against one another and wonder about the results. As we become more certain about them, some facts become ideas and then tools for people. In my work the photographs came first. They are the facts. This book and the ones to follow are the tools. My process is to shoot first and ask questions later. It is the American way.

Why a Camera?

I t is important to get to the point. Suppose, however, that there is no single point to get to. Imagine a subject with numerous aspects, all potentially equal in value. The problem is to clarify the subject, make this multiplicity clear and valuable, and remain coherent. How? As I am writing this in my garden, a hummingbird enters to navigate the circuit of bee balm and coral bells. He hovers eight feet away and stares at me with the answer—constant motion.

<div align="center">✳ ✳ ✳</div>

For Americans, ideas lie in things. The assertion belongs to William Carlos Williams, but the evidence is there for anyone to read, that Americans as a people are singularly devoted to material goods. If one could characterize a European intellectual position as "What do I know?" or "Why am I here?" the parallel American posture would be "What's this?" or "Where am I?" Americans are very physical, more body than brain. This imbalance sometimes causes problems, but it is as reasonable to start a logical process by grabbing hold of a thing or looking at a place as it is to light upon an arbitrary point of metaphysical speculation. Americans are the unforeseen heirs of Francis Bacon.

It is an easy task, and one often undertaken, to focus on the physicality of American culture and indict its materialistic aspects. It is a harder task, and one that is less attractive to people whose world is largely intellectual, to examine this physical energy to see if it could be tapped for higher purposes. Breaking horses to the saddle and bit is an American habit more so than breaking objects to positive intellectual use. Nonetheless, why not mount something physical and ride it to understanding?

I believe that the idea of being human developed and is developing from the slow accumulation of human things. One thing literally leads to another, a new idea springs from an old; in everything human and new we can see traces of what has gone before. Those things and the spaces in which they exist—the specific and different ones each of us knows—make us what we are. It is *place*, the relationships of things in space, that shapes how we see. It is true that factors such as language, religion, and social 3

strata give us attitudes about what we look at. Nevertheless, in a largely unexamined way, the raw visual pattern of the stuff that surrounds us is the foundation upon which these attitudes stand, often shakily.

We are Americans because we live in an American space shaped by the dreams, deeds, and intentions of people long gone. We live in houses that enclose their ideas of home. We travel roads that capture an anachronistic spirit of moving on. We work in places that look as they do because our ancestors chanced here upon a unique confluence of open land, machine power, and a political system that favored utilitarian experiment. The accumulation of things left by generations of Americans weaving their hopes into this place created the landscape in which we live. This landscape is a precondition to how we see the world. Its patterns produce the rhythms of our vision. And as I believe that how we see is very much who we are, in this way our places give us character. They bond us to the past and future and continue to elude our perennial questions of ''What's this?'' ''Where am I?''

As my photographs accumulated they were the things I first grabbed hold of and asked, ''What's this?'' My photographs showed me the shape of a type of thought. The words I use here, the design of this book, the strategies of this essay, are afterthoughts. I needed to realize I was an artist before I could start to think about what it was to become one. I needed also to have done something coherent before I could think about how to do it and what it meant. My notions of usefulness have grown out of the logic of experience with physical things and not out of the logic of ideas. I have spent my working life, though, handling both.

The tools I have used most frequently as an adult are words and cameras. I was a lawyer, and I am a photographer. I practiced law long enough to realize it was driving me mad. So I stopped being a lawyer. And became what I am now. At the time, the change felt so total that it seemed I had returned to Earth from another planet. The difference lay between a world of abstraction shaped by language suited to the arbitrary needs of a client, and a world of things that stood with their meanings latent at the gates of the senses. The law required consciousness of form, but it did not require *belief* in anything. I needed something I could believe in, and I was not finding that in a life built around the rationalizing of other people's facts. Perhaps I merely wanted facts of my own.

In any event, I stepped off the abstract path of law onto ground marked not by fiat but by the clear tracks of a handful of individual working artists—tracks that spread in various directions, marking lives spent in the service of some meaning larger than personal appetite. It was silent, filled with light, and felt like home. I started walking. Literally.

As I moved into this space I passed through a period, while still in the sight of the law, where I thought I knew my location and direction. I was an artist bound for the places of artists' business—galleries, museums, private collections—places I had come to understand while practicing law for artist clients. Then one late October afternoon at the Jersey shore, pursuing the site of a memory from my early childhood, I lost my sense of direction and found myself, metaphorically, on a path that with its rhythmic loops and switchbacks caused me to exchange artistic ambition for hypnotic fascination with things and their spaces. Almost immediately my photographs became densely layered, affirmative though ambiguous, and true to my eye. They acquired a specificity that convinced me to replace belief in myself with faith in the work. And I forgot that I'd strayed from a known path and that I'd wanted to be an artist in artists' places.

The experience that remapped my path, but not (as I know now) my direction, was that in the midst of making a photograph I stopped talking to myself. I stopped, it seems, a river of language that had run forever in my mind, coming between me and the world. There had been words endlessly at work in my head: words spoken, sung, chanted, barked—my voice and the memory of others, declaring, questioning, labeling, narrating, debating, warning, rationalizing, rebuking, theorizing, translating, drowning in abstraction whatever I might have my hands on at the moment, making me more a committee than a man. And then, all of a sudden, I was alone. I could see things for myself.

That first experience was singular, and because it was unique to me I didn't catch its pattern. However, it returned again and again until I knew its shape and could call it to use as I needed it. The process of identifying this wordless state of mind was made easier for me because I had been through an analogous mental rewiring in law school. There, under the guise of teaching us contracts, torts, taxation and the rest, the faculty led us to think like lawyers. Thinking like a lawyer is a very special and specific state of mind, free of expectations and judgments. A state of mind in which facts can float free, almost, of the laws of gravity, space, and time, so that their final order of presentation can best fit the needs of a client's chosen view of things. This state of mind is a marvelous skill, whose openness to life situations is nearly poetic in its ability to generate reality out of unexpected juxtapositions. It is a skill, also, that anyone can learn. More right-minded people ought to. It is good in and of itself and better yet in that it makes accessible to us different possibilities of mind without requiring that we withdraw from our place and time. It establishes the potential that one can tune the mind, like a radio, to receive different versions of the facts. The ability to scan a mental dial and compare versions increases our chances of finding something real.

When I became a photographer and realized that I could work coherently with the facts of the world without subjecting them to a running narrative, one part of me went to work in silence and another part ran off to talk about what was going on. But the part that was talking spoke only about the process and not about the facts of the photographs. For the first time in my adult life my eye had the opportunity to speak on its own, not as an adjunct to something that words could decipher. With a convert's abandon, my language bent itself to theorizing about the visual mind, to arguing a new role for the camera, and to making the obvious point that photography was not like the practice of law. As I know now, I was wrong about this last point. I will take it up first.

Law does not appear to imply photography, but from my point of view it is difficult to talk about one without talking about the other. The congruence between them came to me because I regard myself as competent in two areas of endeavor on which nonpractitioners like to hang the label of "lie." Photographs "lie," and lawyers have been called liars since the first one named a price for the use of his tongue. It struck me that if this label were true, then in some important way I had not moved very far in this leap I had made into the silent intelligence of the eye. Thinking about it, I concluded both that the labeling was wrong and that, nonetheless, I hadn't moved all that far; or, that I had moved quite far, but that my new path, in the pattern of a double helix, had been crossing back and forth over the old without my realizing it.

Some parallels are these: photography and the law are machines for examining facts. They don't lie, instead they play on the too-ready assumptions of single-frequency minds. They are not witnesses to truth: they make truth *possible*.

As machines for examining facts, as processing systems, the two disciplines mirror each other's postures of reaching for truth. Each has a characteristic grid for standardizing our approach to the facts under consideration: the rules of evidence and procedure in court and the rules of the physics of light in a camera (a word that interestingly enough refers also to a judge's chambers). Neither, however, has an enduring reputation for honesty. This is because they share a neutral gaze.

Both photography and law have at their center an understanding that the "truth" of any fact or situation lies amid a potentially infinite number of points of view, all of which exist simultaneously and independently of one another. Law recognizes this and has established a *public* process to decide on a truth we can live with when points of view are in active conflict. The process acknowledges the simultaneous nature of differing beliefs, with each side laying out in detail, over time, its attitude toward a set of facts. Biases and inconsistencies surface in the battle. Law is rooted in the belief

that finally we cannot know but must choose between. Justice is possible, not certain.

Every photograph is also the result of a process of choice among simultaneous realities, but it is a *private* choice. And while it is presented as an instant, it too is the result of far longer human experiences of place, time, and purpose. Nevertheless—and here lies the parallel to the single-frequency mind in a court of law—because we all make photographs, we share a strong tendency to assume that what we see in an image is what we would see and record had we been in the photographer's shoes. We see it as if from our point of view, and therefore as true. This is why travel brochures, for example, are effective; they play on this assumption. This is why travel brochures disappoint, also, for only the rare viewer regards the point of view in an advertising image as a bought one, a deliberately selective one, just as a lawyer's narrative is in the courtroom. Photography is a method of *approach* to the world, a way of thinking about it, and not, by itself, the truth. A photograph is not proof of something; it is evidence to be tested on the way to belief. Photographs are facts, and honest in their fashion, but only possibly true.

Even if we disagree on the amount of deliberate misrepresentation in photography and law, I think we can agree that simply raising this perennial issue of possible truth reinforces the argument that both fields, in their processing of facts, are involved in a search for order. If we feel misled, it is because we have too easily followed a trail of evidence, too readily dismissed the other possible paths and markers available to us. What is of concern to me here, however, is not degrees of honesty, but the appearance, at least, that photographers and lawyers share some patterns of thinking.

A photograph, while recording a single point of view, can maintain multiple layers of evidence and meaning. We can examine this evidence and argue its meaning with regard to the photographer, the viewer, the subject, the medium of photography, or any arrangement of relationships among them. A photograph can hold for us the simultaneous truths of the world. Its layers of possibility permit us to follow a thought to its conclusion and then return to the image to begin anew with a different thought, which may be the antithesis of the first but equally valid. The more ways we can see into the image, the better we can know the different patterns that bring order to the world.

I am interested in order, in how things come together, in how we shape our attitudes toward facts, and in how facts shape ideas. In choosing to be a photographer I unwittingly took to a path that repeated a mental pattern I already knew, one that dealt with the order of things. And in choosing to restrict my photography to the things I happened to pass as I traveled America or walked on errands in my hometown, I

generated a visual record of the space in which I lived, the places and things that shaped my metaphysical wandering, much as roads curve by rivers or cling to hills. It is fitting, I think, that this field guide begin from home ground and that its direction come from the eye, which stands at the heart of the real.

I want to turn to the eye now, and to its machine and mimic, the camera. Together they have formed the most distinct threads of memory trailing away into the past when I turn to see if there are reasons for being where I am.

✳ ✳ ✳

We are born into chaos, into a hurricane of sensation. Upended, slapped, filled with first air full of the world's noise, we find ourselves flooded most powerfully with light. In the womb we can hear, and we respond to prodding, but we float warm and blind in the dark. Suddenly the world is cold and dry, and things are very, very bright. Suddenly we have a past, and for the first time it is up to us to find order in the world and become part of it. The friction of unknown rubbing against unknown must cause a fire in the brain when the eye is open. I don't see how we could ever know for certain, but I think that getting control of this fire would be of highest priority for the infant brain.

I believe that we are born wanting harmony and that we seek it all our lives. One method of establishing a sense of order is through sound. Mother sounds first: lullabies and odd doveish noises while we lie with eyes half-closed and an ear near the heart whose measures once filled the womb. It seems to me as reasonable as not to argue that the memory of this blood rhythm, this fundamental pattern of life, plays a role in sparking the infant brain's search for analogous orderly structures in the world. Even if I am wrong in fact, I think I am right in spirit. It makes sense to me to begin with the senses.

From our earliest moments the sounds we hear and the things we see are the stuff out of which we establish an idea of order. Sound leads quickly to the patterns of language and communication, but I am more interested in the business of seeing, because I believe that our eyes' patterns are secret from most of us throughout our lives. It is easier to infer a connection between an infant's state of mind and a sound that both infant and adult can hear than it is to draw conclusions about the effect of the visual environment on the infant brain. For example, we sing a baby to sleep instead of shouting at it; the relationship between soothing sound and lulling effect is obvious. It is worth noting here that this sound is under adult control and that the infant cannot

block it out. With the eye, however, we can never be sure which element of the visual environment (e.g., color, line, shape, edge, motion) has engaged the infant brain. We can lure the eye, but we cannot direct it. Nor can we be certain from what the infant is disengaging itself when it closes its eyes or turns away.

The business of sound and sight and how we shape reality is also the place of first compromise with facts. It is where we begin to live as people, and, as we become more certain of ourselves as part of a social order, it is where we begin to die to the physical world. It is our parents who first preside over the process. Their voices shape our understanding of the world. Their words cool the fires in our brain ignited by the things around us. Their names for these things provide us with something to talk about.

The sharing of language gives us entry to the structures of human culture. In doing so, it rewards an allegiance to its system of ordering in a public way that no other system can match. And it dictates the parameters of life. It turns our heads by setting the terms for what we can think about. The adults in our lives give us language as a password to being fully human. They must. But if they do it right, if they are of subversive bent, they will leaven the process with questions. They will encourage perennial doubt so that in the maturity of years, if the light is right, language will falter in the face of experience and the names for things will turn on themselves and let the mind alone. Not that we will go mad—simply that when we are strong enough to bear it, we can return to our senses and make up our minds for ourselves.

It is my belief that what we call "mind" is a set of discrete forms of intelligence. Each of these has its own structure, and they are all in motion, swimming through a sea of memory and desire and brushing against each other in changing combinations. Most of them do not depend on linguistic structures for their identities or structure. We know what we know in music, in cuisine, in art, for example, whether or not we have words for the knowledge. This knowing results from some form of mental integration that is as logical within its own context as language is in its; but, the context being different, the shape of the logic is different also.

Of the many different kinds of thinking that there are, however, only the one that gives us language has the hubris and the tools to claim conscious intelligence for its own. Those things beyond its comprehension it categorizes in terms such as "emotion" or "instinct" and dismisses as possible thought. Confronted by the products of a Mozart or a van Gogh, linguistic intelligence may occasionally equivocate. In the end though, it will try to persuade us that only because we can talk to ourselves are we thinking and that because we can *say* something, we *know* something. Language would have us be madmen and lawyers.

Language has its force in part because it does not require a physical tool to structure its message—it needs no violin, no paint brush. Its power to conjure ideas in another brain, a power we all share, verges on the magical. We fall under its spell as infants during a time when the sounds we hear our parents make are *direct experience* on a par with tickling, feeding, and making faces. It is only later, when the naming of things begins, that these sounds become an introduction to abstraction, to human ideas, and begin to wean us from experience as a guide. It is at this point, the point where culture begins, that I believe we first lose contact with our diverse intelligences. It is here that we begin to live in a world of general information rather than specific knowledge. It is here, paying attention to what we are told, that we first deny our blood and its rhythm. Sooner or later, however, like a peculiar motor noise we try to ignore, these rhythms will show the effect of their presence.

Too often we think we know something because we recognize it. *Knowing* something is the result of time spent and intelligence invested in the experience of a thing, a relationship, or a circumstance. *Recognizing* something is often the shallower, quicker process of accepting a report of it that does not necessarily result from experience. When language is the vehicle for a report of experience, it is the *translation* of physicality or an event into words. It is no substitute for the real thing.

Language can be specific only about sound. I can say "I will sing you the note 'fa' " and do it, and convey to you thereby that one specific thing contained in the general class of "note." I can say the word "face" and then "her face" and then "her tanned face" and so on in ever more fractional distinctions, but I can never convey in words what you would *know* in an instant's glance at that face or at a photograph of it. On the other hand, if that photograph were of a face in the process of singing the note "fa," it would convey no sense of that meaning without some verbal explanation and demonstration. The same sort of thing is true of the word "hamburger" or a photograph of one, as opposed to what you know by taste when you bite into one. The word "hamburger," repeated over and over, might make a quintessential American mantra, but it would not make a meal. Things we do not know directly in the medium where they exist, we come to know in the half-light of translation. Language is efficient, but it places us at a remove from the world.

Before we reach the stage of processing verbal reports, the world is ours directly. It pours in on us through skin and tongue and nose and ears and eyes. The senses of hearing and sight are alike in that each is an antenna tuned to recognize oscillations of a specific type within a specific range of frequencies. These senses are different in that each is designed for a different medium and in that only hearing has a corresponding

physical structure—the voice—that permits us to communicate in the same medium
through which we also experience the world. For example, we hear a tone, we can
sing the tone back. With sound we can test between us whether or not, quite literally,
we are on the same wavelength.

What a child hears, a child says. With hearing feeding the voice, we have an
elegant system for establishing, testing, and reinforcing our sense of reality in an un-
developed mind. We cannot do this with vision. The eye has no natural voice. There is
no visual counterpart for the verifying experience of sound and language as they move
back and forth between child and adult. A child's eye may be drawn to the motion of
a branch of spring-gold leaves against the deeper green shingles on the side of a house,
but if he points, a name-conditioned adult will likely tell him he is looking at a tree.
He is not seeing a tree, of course; he is seeing maybe color, maybe lines in the air,
maybe a sense of indescribable relationships created by the world in motion. This sort
of seeing is how a child flexes the muscles of vision. Nonetheless, as a child points, too
frequently an adult will act as though the child has asked for the name of a thing and
will respond with a word that gradually, as the child learns the game, narrows how
and what the child sees.

The eye is not lost forever, though. It continues its "idle gazing" and continues
to shape a part of our being, only it does so mostly without our noticing its existence.
When we achieve speech, we have come to the pride of knowing the world, or at least
the words for it. So we pay little attention to an intelligence network with the potential
to undermine our new-found sense of place and order by questioning the appropriate-
ness of our linguistic categories. The eye carries on in secret and waits for language to
become hollow and for the light to be right.

Thus we become prisoners of naming. It is the price that efficiency and our
culture exact. It causes us to shape our lives around those aspects of the world for
which we have a vocabulary. Those things we cannot talk about tend to slip beneath
our interest. There is a seductiveness and a certainty to learning about the world
through the repetition of sounds, but as a guide to reality, it is misleading. The world
does have sound, of course, but it is not language. Our experience of the world is
something for which words are the faintest of translations. And when, as with the child
and the tree, the translation rests on a misunderstanding, we set ourselves at not one
but two removes from life.

Language caters to the human desire for certainty. It rushes to resolve situations
in which we face doubt. It works to give things a fixed character despite the inevi-
table alterations that time and changing context bring about. Language can pin

meaning like a butterfly to a board. But if meaning is not in motion, we are looking at death not life.

<div align="center">✳ ✳ ✳</div>

Life has rhythm. It moves. So does the eye. It is one of the eye's characteristics that it favors motion. It registers movement—a sudden flicker of light, the dart of a hummingbird, the roll of a hip—with greater speed than it registers the visual features of things at rest. The eye knows that life moves.

But the eye is more than simply tuned to motion in the world. It moves on its own and constantly. It is a hunting organ, an active, dancing thing. It plays over every space we are in, every object we encounter. It is my belief, and one that photography has delivered to me, that while we all experience a visual world created by a moving eye, each of us does so in a different way. That is, all of us have a different order, a different rhythm in the way our gaze searches through the world. Each of us, then, as our eyes glance off surfaces at different angles and at different speeds, sees a different world, or, at least, sees the same world but in a unique pattern.

It is the uniqueness of our visual patterns that interests me here. I would argue that each of us has a pattern of visual inquiry that is as identifiable as a fingerprint, as characteristic as a gait, and that this repeating rhythm of inquiry helps to shape the way we know the world. I think that within this pattern shaped by facts and time, if we could but read it, lies the potential for a sort of reciprocal mapping of ourselves and the places we make our own. However, because our training is to recognize, name, and do, not to *see,* few of us have access to this process, which is central to that independent part of mind which is visual intelligence.

Samuel Johnson said, ''God sent us here to *do* something, not just stare about.'' It is a remark freighted with cultural bias, but appropriate to a man both devoted to language and nearly blind from infancy. Countless people have echoed his sentiments, usually to harass into recognizable activity some apparently fog-bound child. When I was in my early teens, my father frequently made unfavorable comparisons between my staring and that of a trout. Thus are we marched away from learning about a part of us that is as fundamental as breathing—the rhythmic pattern of the eye in motion.

Whatever my tone, I am not arguing here for the elimination of language. I *am* arguing that our reliance on language for knowledge of the world has gotten completely out of hand. It is much like the kudzu vine brought in for erosion control, which would cover every square inch of our southern states were it not for the eternal vigi-

lance of the people there. What I am pressing for, especially in the area of seeing, is the recognition that processing sensory data is a rational, nonverbal act with a logical structure different from that of language but of equal interest. My quixotic desire is to encourage the enlarging of skills for testing the evidence of our senses against the reports of writing or speech.

All thought is framed by pattern. Even students of chaos are finding that things fall apart with mathematical predictability. The different types of human intelligence play out their thinking in reference to patterns they find in the world; only a divine being could shape thought in a void. To my mind, the beating of a heart, the rhythm of a lullaby, and the meter of language represent a line of development in the shaping of one form of thinking. The infant eye dancing to a mobile, the grace of a gaze absorbed in the attributes of a tree or a masterwork of painting represent another. The exercise of the powers of language is open to us all. The eye, as I said earlier, lacks a natural voice. But if I am right in believing that the eye thinks, it would be a worthy human endeavor to build it an artificial one and see the patterns of what it has to say. I am persuaded that the camera can be that voice.

As I think I have shown, language expresses a way of thinking that generalizes the things of the world, and which we permit to place us at a distance from experience. Precise communication by language requires that the speaker and listener share not only an understanding of a word's definition and usage but more important, an experience of the world that permits each to know what the other is talking about. A person's sense of the word "river," for example, is different if one has grown up in forested land along the trout-rich, rapid water of the Wolf in northern Wisconsin than if one's childhood was spent in industrial Ohio on the Cuyahoga, a body of moving water so chemically rich that occasionally it bursts into flame. Simple things like body height, too, affect meaning. I have a friend who is 6'11" and another who is a full two feet shorter. As they walk through the world, their sense of the word "nose" is colored by what they see. One experiences a cartilaginous ridge underlined by lips, and the other, nostrils bracketed by eyes. Imagine, then, how differences of age, sex, wealth, education, geography, and so on affect our understanding of other simple verbal symbols. It goes some distance to help explain war and the presence of lawyers.

Photographs, on the other hand, are the product of a way of thinking that deals in specifics and represents a direct experiencing of facts. My photographs of the Cuyahoga and the Wolf would not constitute an experience of the facts they depicted, but they would communicate a report of those facts without any need for a "translation" from the sense of sight within which I experienced the actual rivers. A recording of the

rivers' ambient sounds would serve analogously for the sense of hearing, as would samples drawn from each serve the sense of taste.

Two things are of immediate interest to me in this photographic episode: one is that I am communicating *by means of a sense through which I had an experience,* a sense that did not require language to frame what it knew; the other is that the tool I use to do this, the camera, is an easily available commodity. A snap inference we could make from this is that you could go to the rivers, stand where I stood, and see exactly what I saw and how I saw it. The implication is that if you had a camera like mine, you could and possibly would return with the same images. This common perception, so democratic in attitude, is one of a number of mistaken notions about the nature of photography, but within it lies the possibility of thinking about the camera, the world, and ourselves in a different light. Within it lies the opportunity to see physically the meaning of "point-of-view," to understand that what we have most in common is infinite difference. I will move circuitously toward this possibility.

The idea that a photograph is little more than a chance convergence of film, fact, and light, is, I believe, widely held. This notion is due in great measure to the fact that we nearly all use cameras. Because respect is often a matter of distance, we have, I think, little regard for a product we feel any one of us could have made with a push of a button. It is one of the minor ironies of America that the more democratic something is, the less we value it.

For example, we place enormous value on painting, a medium of visual communication that is the province of a gifted few. Painting speaks to us from a distance. No matter how common its subject (whether idea or thing), it is still fundamentally about the miracle of its own existence, and about the divinity of some artist's wrist. The aura of its maker's presence is often its most important fact.

Photographs, outside of art circles, seem to be less about a maker or an idea than about the thing in the image. Certainly we can read photographs for their elements of personal expression and the strategies of design; in fact we must. Nevertheless, we commonly look at photographs to see what they show of some piece of the world rather than to satisfy our aesthetic appetite. We speak of photographs as taken, rather than as made. We see them as the work product of a grubber of moments, one with the good fortune to have had a camera at hand. For most of us they represent luck more than purpose. And they are essentially anonymous.

When we do speak with awe about photographs, we use phrases like the "photographic instant," the "frozen moment," the "capture of minute slices of time." I am awed too, yet once past the camera's trick, past the first few reconnoiterings into the

image, I became gripped by an awareness of the amount of living time that I can devote to the work product of an instant so tiny as to be without identity or moment—save perhaps for its capture.

The image of this instant, though, is mesmerizing. It is a mirrored door through which it is possible to step into a landscape of constantly shifting elements. It begins with an interest in either the thing photographed or its shape *as* a photograph, with a fundamental concern over content or form; but in relation to what can follow, these elements are only the barest beginnings. As one stares longer and longer at photographs, subject matter and design strategies lose their easy, separate fascinations and become subsumed in the more elusive enchantment of the moment held so still.

I say enchantment because I think we tend, as if in a trance, to believe whatever photographs appear to say. I say elusive because a single image speaks different messages to different people, and different messages to the same person at different times. This moment has in it a power to cause the examining mind to look the other way, to roll back on itself, to *change the subject,* as if the image were surrounded by some barrier that the eye can cross, but which scatters other methods of penetration.

A major impediment to our coming to grips with the possibilities inherent in the camera has been the strength with which photographs have resisted verbal analysis. Photographic commentary is marked, more than anything, by disagreements over how to categorize camera-made images. At first I took these disputes seriously. Later I regarded them with more distance, for the images under discussion seemed to exist solely for the sake of the language pursuing them. Now I see the endless debate as simply another human activity with the energy, but without the structure, of the practice of law. Photographs prove so elusive to those who would talk about them because the photograph is the product of a process of visual reasoning, and the shape of its meaning is not the same as the shape of language. Photographs prove so elusive to those who would read them because it is rare that we can see them in a way that reveals the working forces of the visual mind. In galleries and in print they too often appear as if they were sentences built with subjects and objects but devoid of verbs, adverbs, adjectives, or punctuation. What is missing is a sense of modulation and human time.

Painting represents, brushstroke by brushstroke, significant time out of an artist's life. There is significance in the fact that the painting—the thing with which we engage visually—reveals in the layering of its surface that the resonant power of the work results from a slow accumulation of greater and lesser decisions. The force of music, too, lies in the gathering, over measures of time, of tones and silences that form a moving pattern. Language itself is the development of an order of thought by means

of words laid end to end whose strength comes only through temporal analysis of syntactical pattern. Unfortunately, we don't see easily an extended process of time in photographs.

If there is value in what I am saying, then it is the context in which photographs exhibit the accretion of time and experience that we must examine next. That context is the natural eye of the photographer made visible in the patterns of a body of work, and the living eye of the viewer as it finds and begins to move in time to the photographer's rhythm of inquiry. Here, time is of the essence.

The attitude contained in the phrase "photographic instant" has diminished our ability to recognize that a photograph is potentially as presence-filled, as layered a piece of work, as a painting, a fugue, or a poem. Individual photographs have convinced us of the facts they show, but it has taken armies of words to build a frail bridge linking photographs to the terrains of showplace and academy occupied by painting, music, and literature. It has been a dubious triumph for photography, one gained at the cost of being valued for itself alone.

Photographs, putting facts at eye level, show us ourselves—in William Carlos Williams's words, "Ourselves made worthy in our anonymity." When we deny that anonymity, when we declare a photograph to be art, we are in danger of losing the freedom that anonymity provides. On the other hand, when we leave something unexamined because it appears to be anonymous, nameless, we are in danger of overlooking a source of great power. Photographs can show us something of what it means to be human if we take them most seriously when they are pared down to the shared essentials of life. If they are in fact art, they will provide us with a place from which to begin testing the honesty, the worthiness of what we've been told.

We, all of us, reach a place naturally in the course of our lives that is part of the landscape around every human path. It is shaped by the pressure of time on fact and given character directly in proportion to how much we reflect upon those facts. The place we arrive at is one of maturity. It opens to us when we have experienced the world long enough that its light and spaces have taken on resonance. The process is much like that of a musical note moving among the spaces of a Gothic cathedral, when the sound waves, reflecting off the stone fact of the place, reverberate and give the note a flavor that is part tone, part place. Our eyes, ignoring language, move in a singing line through the world and experience similar reverberation as they glide time and again over the world's facts. And photographs have resonance directly in relation to the living experience of the photographer and the viewer. The "photographic instant" is the length of a lifetime.

We reach a point in our lives when the nonverbal experience of facts rises to a pitch of intensity impossible to ignore. It is like an architect engaged in an on-site study of structural forces in cathedral building, who for the first time knows the meaning of the place when his mind suddenly lifts free on the waves of a Gregorian chant.

I believe that moments similar to this occur for each of us no matter how different the specifics of our lives. Some of the events we label ''life crises'' are the unexpected surfacings of aspects of mind from which we turned away years before. Some of the problems ascribed to middle life are due to a sudden perception of the distance between accepted but limited descriptions of the world, and the multifarious nature of life and its facts. This cognitive jolt is a problem only if we refuse its offer of new pattern and instead call it dissonance. The offer is a choice between degrees of life and degrees of death, and it involves accepting new responsibilities without abandoning old ones.

If all thought is framed in pattern, and if we accept the idea that pattern makes itself known over time, and if we accept that time is a form of motion, then thought lies not in what we think we know, but in the passage of mind through the space between a question and its answer. Thinking is the left side of an equation, where things move about, multiplying, dividing, changing states. The right side of the equation brings thought to a halt if we are looking for an answer, or to a new problem if we enjoy seeing an unknown factor in motion. The adult naming a tree for the child is an example of an answer, and a wrong one, to an interesting problem. That the eye persists in its motion is an example of a problem that will not go away.

So one day the light is right and a crack appears in the world. If we have the will to pursue it, we can widen the crack, split the world like a carapace, and stand in new skin. Then we begin again with a fresh eye for old facts.

✴ ✴ ✴

A camera is the most democratic tool of visual communication ever devised. Its gift to us is its relentless specificity and universal accessibility. It offers us for the first time in history a way to exchange points of view on the facts of the world without sliding into the generalities of language or the distortions of talent implicit in what we call art. Its often-recognized problem lies in its apparent quality of being merely instantaneous. A more complicated but more useful way to think about this is to say that photography's problem lies in its use as an illustration of our conclusions, rather than to represent the temporal aspects of visual thought. That is, with photographs we are most often looking

at the "answer" side of the equation of sight. We want something known: a snapshot of mother, a record of the Tetons, a bit of proof for an aesthetic position. They are all the same if they don't set the eye in motion, set it to exploring the unknown. And if they don't set the eye in motion, they fail to communicate the thinking process of the photographer and thus obscure the labile nature of what a photograph means. These images, then, become the equivalent of trying to learn to dance by looking at a photograph of Fred Astaire.

This book is, among other things, an attempt to provide an experience of the visual rhythms I have experienced. I make photographs in a process that is mostly movement. The movement is at human speed, the speed of my feet. At this speed, the characteristics of the landscape through which I am walking exert a pull on me that I feel much more strongly than when I am driving a car. I know the landscape as a pedestrian in a way that is impossible for someone thinking within an automobile's framework of time and space. The rhythm of a car is that of a machine. The rhythm of a walker is an animal movement. The point of view of a walker is head high and free, whereas that of most drivers is at the level of a pedestrian's stomach, and caged. The most fundamental aspects of these two approaches to the landscape are so different that it is impossible for either pedestrian or driver to know the same place in the same ways.

This book is about an aspect of being human that is rooted in our physical senses, in something animal. Nevertheless, it is a machine product from its paper and ink to the photographs embodying its ideas. There is a paradox here, but no compromise. Machines color what we know and affect how we live, but they are human products, extensions of ourselves, and thus part of the natural world. Their relationship to us becomes unnatural only when we forget this connectedness and with casual disregard abandon some of our humanity to them. Then these machines, because they rise from our desires and reflect the shape of human intelligence, can control our points of view and distort our lives.

A machine has machine needs. A machine has no need of experience because its role is predefined, and while it may stop, it doesn't die. We need knowledge derived from personal experience because we define our own roles and will die even though we don't want to stop. One of our delusions is that we can avoid death by consigning the inefficient stuff of life to machines. Sometimes all we get for this is the early death of a part of ourselves; but we rarely feel the pain of it because the machine that brings death to one part brings comfort to another. The automobile, the computer, the television save us time by delivering us to conclusions at machine speed. If we are not

vigilant the price we pay for the acceleration of human speed is the gradual disappearance of movement within the human equation. We can eliminate the unknown and deny the unknowable. We can begin to live in a rectangle of cold certainty earlier than I, at least, would like.

A camera is a machine that works at faster-than-human speed and delivers information in cold rectangles. However, its products, while specific, can be anything but certain or conclusive. Seen from the right angle they contain human movement and the potential for evolving meanings. To me, a good photograph has the strength of a clear point of view and the energy of a dancer. A photograph like this is meaning in motion, not the conclusive description of fact or the fixed image of its maker. Photographers can heighten this sense of the movement of life by working with the understanding that there is a seamless connection between subject, self, and camera. In my work, American space shapes how I see and who I am, while the camera is the machine I use to continually extend my understanding of that space.

To see photographs this way, we must break the habits of assumption that channel our interpretations of what we see. We can do this in two ways that interrelate: we can assemble numbers of photographs to see patterns of construction that show themselves only in the context of the group, just as family relationships become more evident when a clan is gathered together; and we can practice shaping new visual grooves in the world itself. I have two anecdotes on this latter point; the former I cover best in the photographs gathered in this book.

When I was a boy, for a time I took lessons in drawing portraits. One day while we were working from a model in class, the instructor interrupted to make a point about how eyes appear in the faces of adults as compared with the faces of children. She said that children's eyes were wide, the pupils fully visible, while the eyes of adults were half-closed. Ignorant of muscular physiology and in the grip of early-teen hostility, I decided that the difference was due to adults' believing that they had seen it all. I also decided that I didn't like half-closed eyes and never wanted them on my face. I figured I could avoid "know-it-all eyes" by trying every day to see one new thing on the walk from the top of my street to my home. It seemed to me that if I could prove to myself I had not seen it all on a daily basis, in my most familiar surroundings, then my eyes would stay open. I practiced this on shapes of hedge and types of leaf, patterns of brickwork, bark, and roofing. I monitored the progress of a tree root heaving the slates of the sidewalk out of line. I cataloged the various window designs formed by mullions and sashbars, types of chimneys, and the details of doors. And I watched in fascination the year-by-year takeover by trees and bushes of the property of a neighbor

whose 1949 Ford hadn't moved from its garage for more than a decade and who, the neighborhood children believed, slept in the basement in a canoe out of fear of floods. No matter how my eyes look now, it is a habit of mine to see things new. The exercise of this skill permits me access to the energy of travel without leaving town or trying to transcend my circumstances.

As an adult and a photographer I was having extreme difficulty making coherent photographs on sunny days. The shadows cast by the objects that caught my interest caused the images to lurch in drunken disorder. For a time I restricted myself to working only during periods of overcast, and produced shadowless photographs as pointed and complex as a nail. One cloudy day I had my camera trained on a lily growing alongside a house. Suddenly the sun broke through the clouds and cast the lily's shadow in a beautiful arc across the frame of the viewfinder. It struck me with head-slapping obviousness that to the camera the shadow of a thing is as real and substantial as the thing which casts it. Later I realized this truth again as I looked at the world without a camera. With this camera-gained knowledge, I saw that I had overlooked the reality of most of what surrounded me.

Shadows and the spaces between what might ordinarily count as significant facts, significant objects, became the country I chose to explore. It is this shadowed space, this vast, nameless, ubiquitous America, that we hold more in common than the few points of coherence we have been able to focus on by name. This American space is the space that driving makes invisible, the territory that was ours as children, before we got the idea that we had seen it all and accepted reports that there was someplace else to go.

This series of books has at its heart the desire to make this invisible place visible and valuable once again. The ground it covers is a landscape that is open to all of us and a state of mind whose form is a common sense. It maps these territories with the same spirit I have seen in friends exchanging data on trout streams—noting riffles, holes, brushy places, speculating on hatches, recommending flies, and relating experiences in the hope of encouraging new ones. More than anything, though, acknowledging by the exchange the understanding that the trout are secondary to wading in the mystery. We keep very few of what we catch, and we stay in motion.

I feel like a fisherman when I am moving around with my camera. I step out the door and check the humidity, note the clarity of the light, think about the position of the sun and the shadows it offers, sense the range of contrast, and move out toward what interests me most that day. In my public work at the moment that means industrial sites, places with water, or virtually any outdoor space that contains people. In my

private work it means gardens, portraits, and the interior of my home. For you it could
be any fact or set of relationships the eye can see. What you look at doesn't matter; how you approach it does.

With individual style, we all learn to use language to communicate a broad range of our interests. We learn over time how to talk about everything from breakfast to philosophy, art, and love. We learn to use cameras also, but for most of us at a very restricted level, in a way that we might use language to make shopping lists or random inventories. It would be difficult for us to do otherwise because this is the approach to photography that we see in magazines, in albums of snapshots, and, too often, in museums and galleries. And most of us, unfortunately, make photographs in imitation of other photographs. It is like being given a dictionary instead of the example of Shakespeare. Grammar, syntax, and the possibilities of individual rhythm would be beyond reach.

The grammar and syntax of photography derive from the shape of the image and the physical limits of camera, film, and printmaking technology. The rhythm of photography derives from the photographer's way of approaching his subject. In the same way that I see meaning in the motion of trout fishing and the meter of Shakespeare, I see meaning in photographs where I can feel myself absorbed, step by step, in the photographer's rhythm of inquiry and so come to understand his point of view.

I first learned to think about the possibilities of visual rhythm years ago while watching a curator friend install a show of paintings. All the work of the artist was spread out, leaning against the gallery walls. I looked at it and thought it was good but wasn't moved to the degree for which the artist's reputation had prepared me. I watched for hours as this friend practiced the art of installation, arranging and rearranging the positions of the work around the gallery. First, two images here and then three over there began to speak to one another, and soon more joined the dialogue. Finally, with all the images in thoughtful visual juxtaposition, the atmosphere became nearly blue with the electricity of the work. This charge could have been the result of the installer's vision, but it felt like the bristling presence of the artist. Either way, I learned that there is a physical rhetoric to the presentation of visual ideas, and that it requires an understanding of the work and an empathy for the situation of the viewer. An installation done with care illuminates the nature of the work and, of greatest importance to me, shows respect for the viewer's intelligence and makes it possible for him to experience for a time a harmony of viewpoints. Just as we might leave the theater humming a tune, we can come away from visual work with our eyes able to follow the beat of someone else's drummer. When this happens with photographs

made from the facts of the world, we are at a moment when that world can crack if we want it to.

The facts of the world are there for everyone to see. Most of us use cameras on some of them, but few of us choose to marry a single subject and become intimate with its daily life. If we were to do so, we might learn as much about ourselves as about that subject. Photographs in focused groups can reveal the patterns that make up a point of view, the "grid" that makes a photographer's or a painter's work coherent. We all have such grids, but few of us have the painter's motivation to plot them and explore their possibilities. Fewer still have the skill to master the grammar and syntax of brush, paint, and canvas. All of us, however, have access to cameras that provide mechanically accurate and reproducible images of potential artistic worth. What I am trying to do with *Common Ground* is to demonstrate that this medium's grammar and syntax can be used to *say* something, not simply illustrate language or decorate a wall. And I am trying to demonstrate that it can be both thoughtful and democratic by beginning my visual statement about America with a subject most of us can come to with ease. Each of us, if we make the effort, can use the camera to bring to the surface some of the unique patternings we use to know the world. Though the process may be prosthetic, the camera can give voice to the eye. My faith is that what it says will help clarify what we've been saying since we invented language to talk about something we saw.

The photographs in this book are made from my point of view. The camera's height was at the level of my eyes when I walk. The images were not made for pay or in the service of some idea I could express in language. They are as close as I can come to communicating a body of experience I believe Americans have in common, but which I find too fugitive for words—something that feels both real and dreamlike and is as direct and transparent as a heartbeat.

When I walk with my camera or when I am alone, and so not engaged in conversation, I set my eye free and follow where it courses. My vision darts through light and shadow, my head turns from side to side, I stop, I start in new directions, I pause every now and then to store in the camera some thing, some relationship that particularly pulls at my eye. When I store these moments I am not fully aware of all my eye has registered, but I am very conscious of where the edge of the picture is. All the images in this book are full-frame and represent my experience with things and spaces, not my thoughts about cropping a negative. They are shaped by the facts, not assembled after the fact.

I am aware, since one thing does lead to another, that each of these photographs is itself a fact. Each of these new facts has a role to play in ordering the experience I am

trying to make possible. In *Common Ground* I have organized the images in a careful sequence to help make explicit this photographer's visual habits, but in a manner that I hope simultaneously encourages a viewer's independent way of looking at the world. I have had to work within the limits of a book's isolating page-to-page linearity, but I am trying to establish a framework inside which my photographs can speak to one another as visual work can through sensitive gallery installation. A number of the images are like paragraphs that sum up ideas. Others represent variations exploring the possibilities of formal hypotheses or factual motifs. I would like the photographs to effect a chain reaction, each image releasing increased energy from the next and none of them ever appearing to the eye the same way twice.

The images in *Common Ground*'s progression divide naturally into five sections of about equal length, not so much chapters as musical movements. Each movement displays its own characteristics but remains part of a whole that has been reworking its themes forward and back again among the images. While the early images prepare the eye for later ones, part of the design structure of the work is that subsequent images will bring out the importance of seemingly minor elements appearing at the beginning. The book is thus less a traditional sequence than a Möbius strip. For me, it does not so much end as begin again, each time with an enchanced sense of the layered nature of perception and of the number of levels of order the world contains. If the book works as a "guide," it is an exposition of the idea that what we think we know is a function of how we approach the facts of the world.

In marshaling the images into this sequence and in restricting myself to one subject, this common ground, I am trying also to make visible my belief that photographs result not from luck and not from instantaneous recognition, but from an interwoven accumulation of moments whose shape is inseparable from the pattern of the photographer's eye moving through those moments. This accumulation is what I experience building up in my eye as I walk through the landscape. It is analogous to the layering of a painting or the ordering of an argument, and it represents living time, experiential time, as opposed to the informational instant. Awareness of this accumulation in time has value as we look from the world to the images or from the images to the world. If it breathes, it is the shape of an American presence—mine and yours, both.

It is also the shape of America from a point of view formed in New Jersey, where I was born and grew up always in the presence of the North Jersey industrial skyline. I was a loner and spent as much time as I could out of doors with a book to read when I stopped somewhere. The place I liked best was an enormous woods that

extended atop a wall of granite cliffs high above my hometown. I would ride my bike to the base of these cliffs, the site of an abandoned quarry, and then make my way to the top along a narrow dirt path. Occasionally, if I carried no book, I would climb a dizzyingly vertical rock wall simply for the sake of adventure.

At the top I could walk on stone that bore the visible scars of glacial scouring. It was breathtaking for a boy not yet in his teens to touch the tracks of these ice rivers and try to comprehend the distance between the world then and the world of the 1950s. And there, past the edge of those cliffs, I could see that world for nearly twenty miles to the east. There was my town hidden under a canopy of tall trees, a band of new and treeless subdivisions farther on, and past them the meadows, the garbage dumps, and the oil storage yards that stereotype the area. Finally, rising in a wall of cliffs itself, the entire city of New York, all of Manhattan Island and more, stretched across the horizon and radiating an extravagance that made this world shaped by human presence as breathtaking to me as worlds shaped by tides of ocean or forest or ice. The marks of these places are on me and in my work.

The work in this volume of *An American Field Guide* is stamped from patterns generated by the spaces of my early youth: the fences and alleys of Jersey City, the light and line of towns along the Atlantic shore, the secret shadowed places that changed with the seasons, the driveways, garages, the back of things, the call of stairways, the textures of leaf and lawn and wood and metal, the edges of shadow and light; skies cut by power lines, invaded by rooftops, tangled in trees, rarely free of the ground, and on and on. And all of it endlessly redivided under the gaze of empty windows, all of it free of adults because it was not the space to *do* things, all of it there for the taking by someone with nothing better to do than look. Even though our experiences could hardly have been the same, I believe that all of us carry the patterns of time spent in those spaces between places; and that those patterns and spaces, which shaped our eye in childhood, represent the possibilities of life and not the certainties of the alternative.

Enough said.

See for yourself.

Common Ground

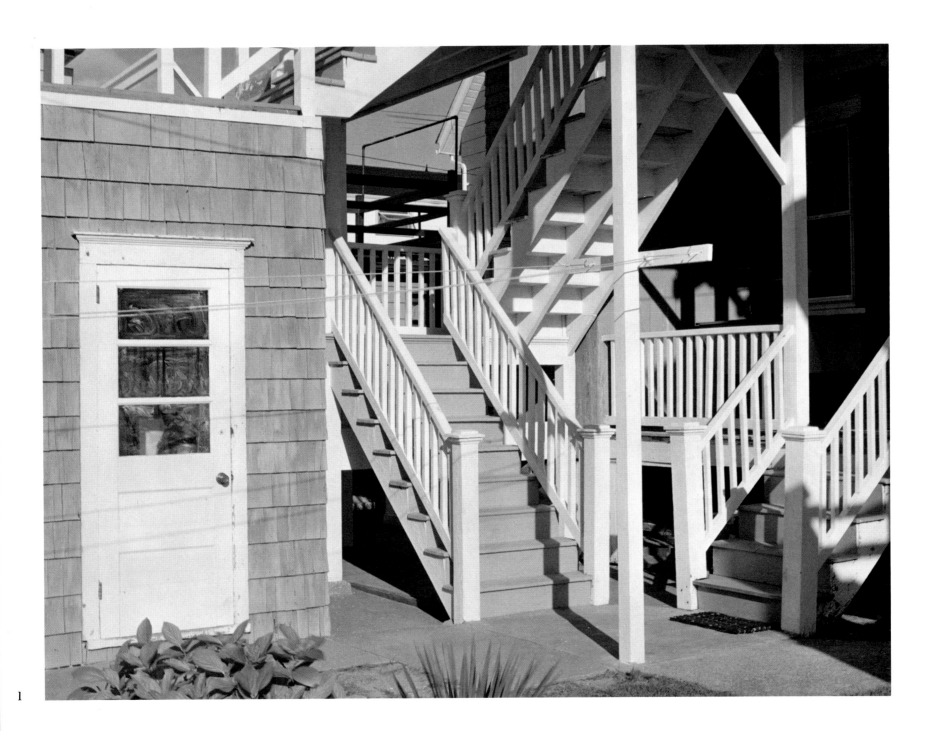

1

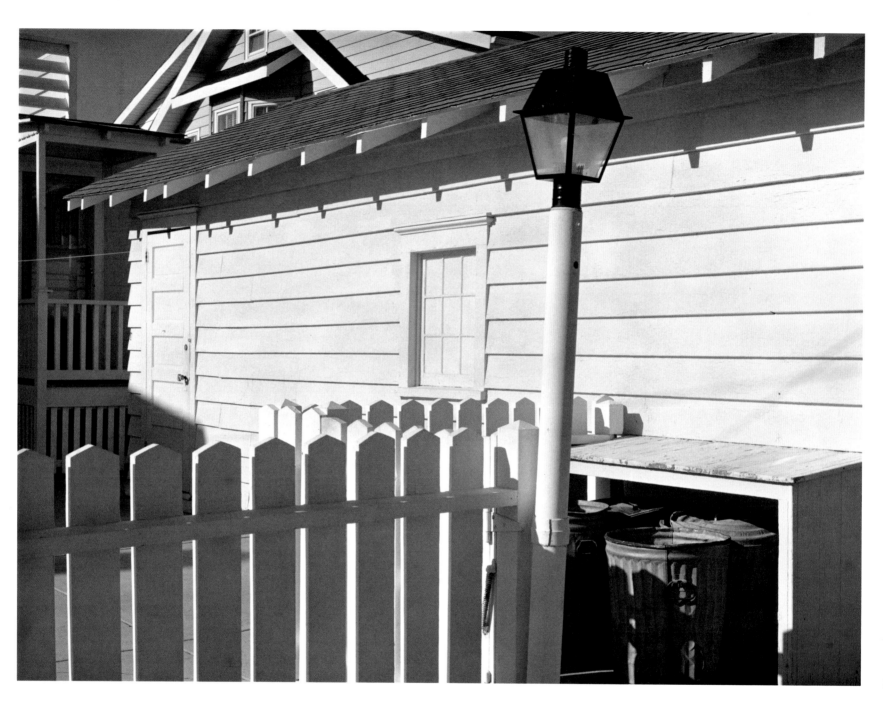

2

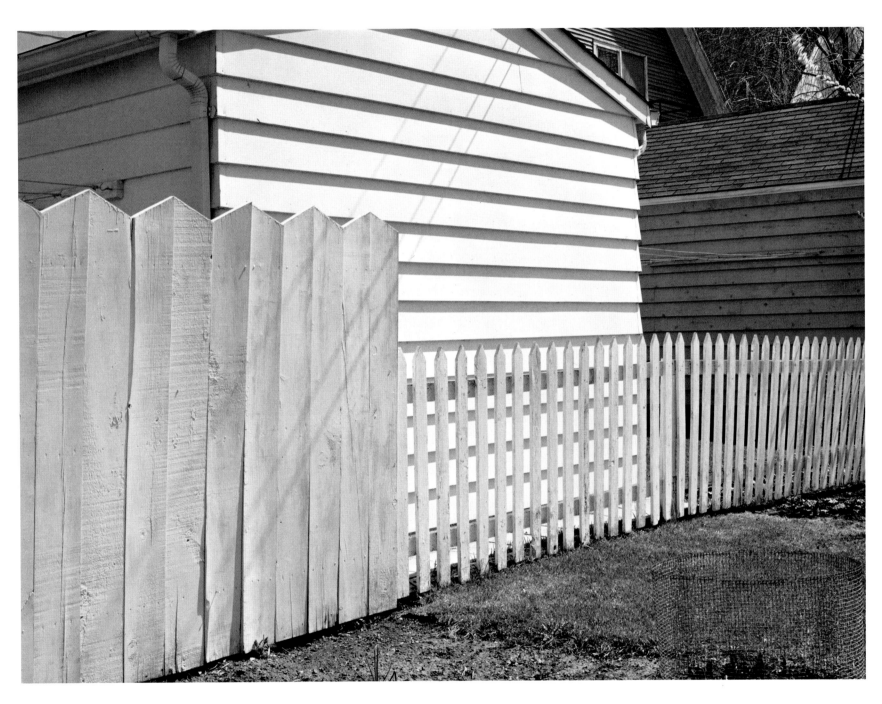

3

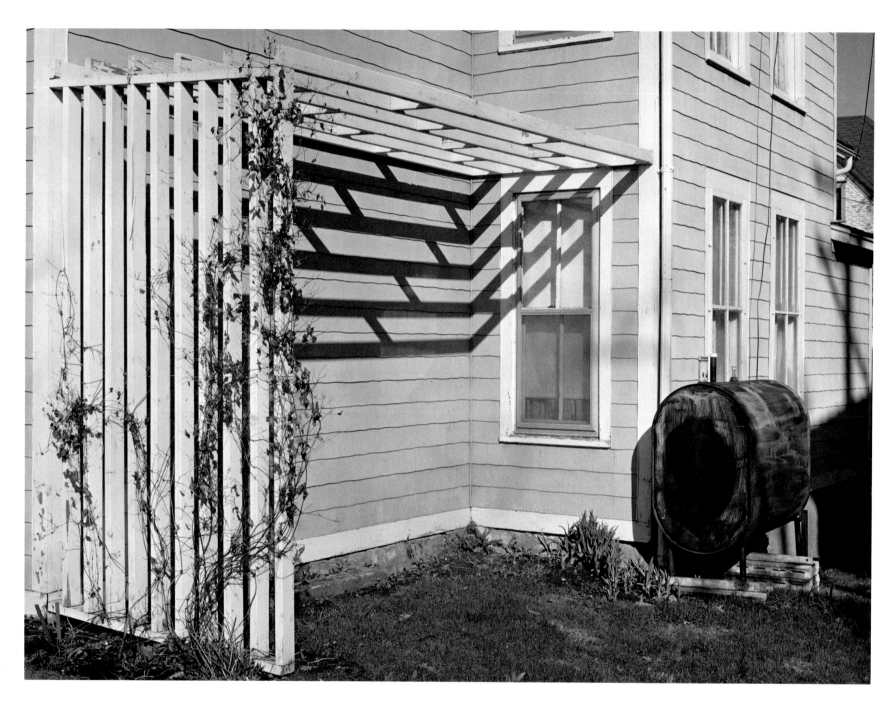

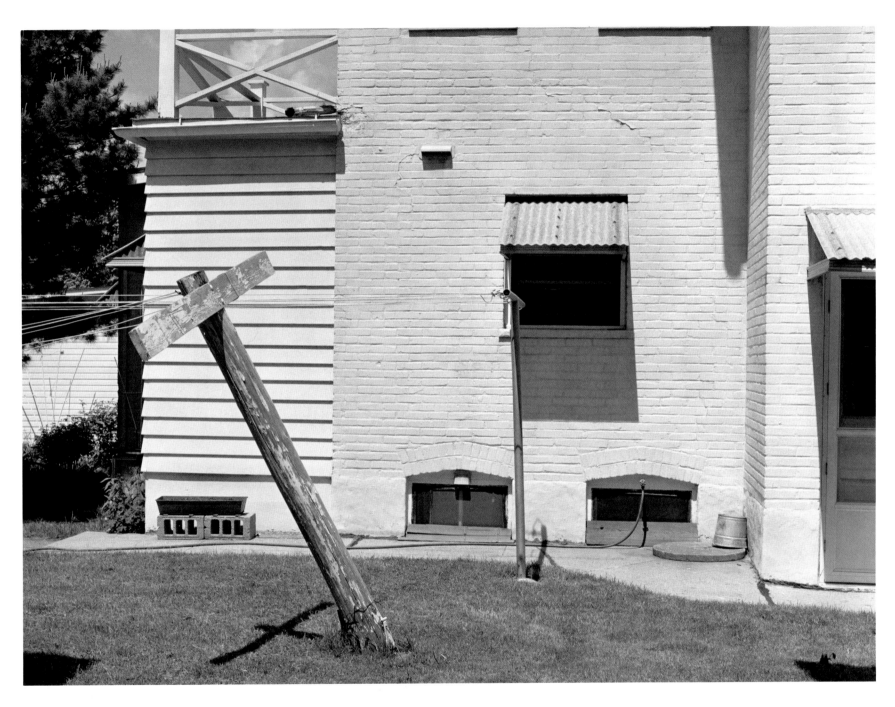

5

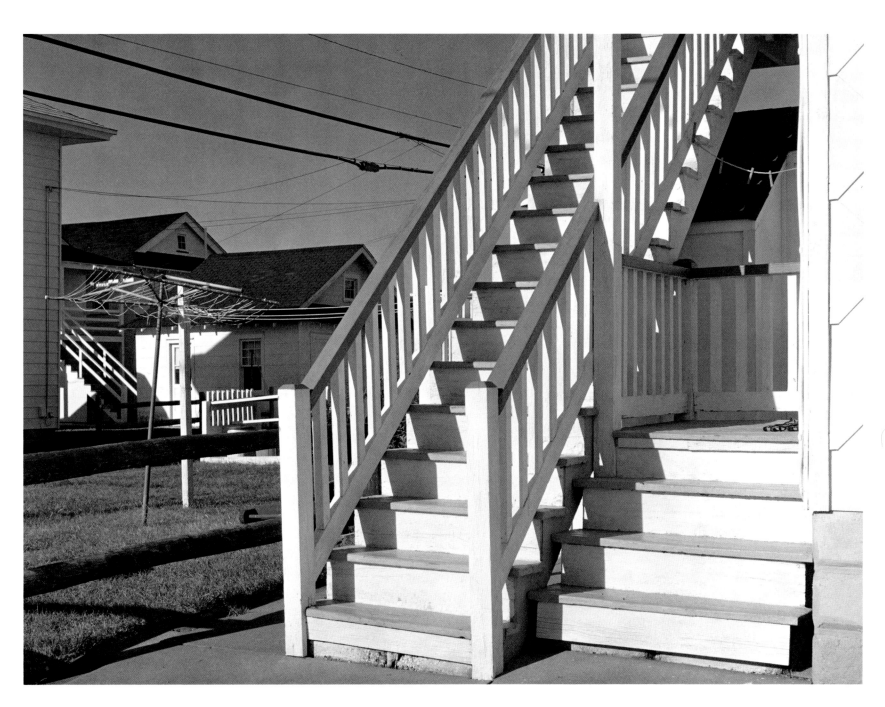

6

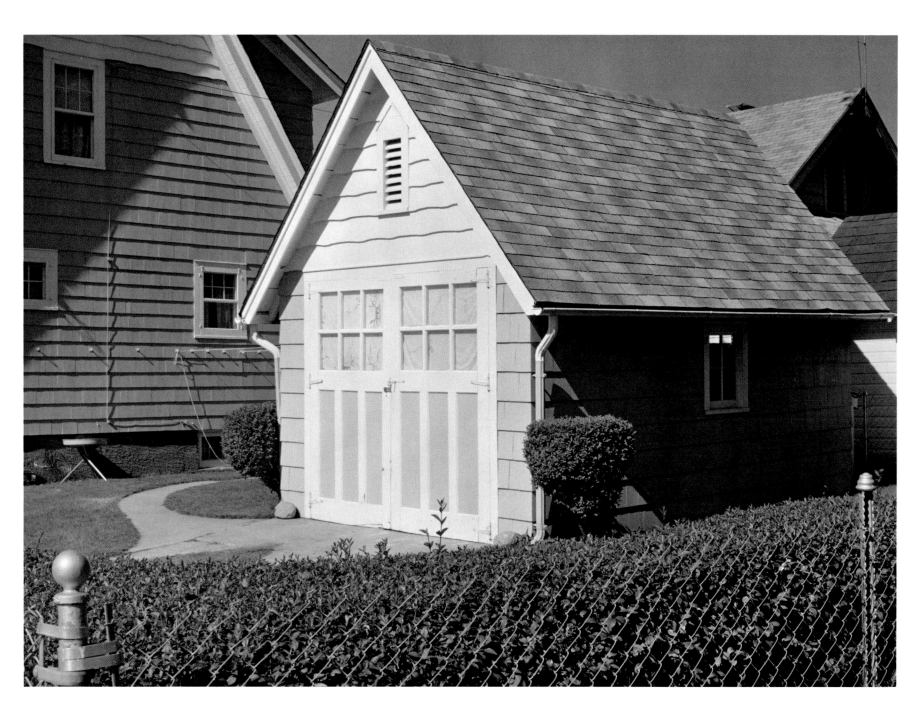

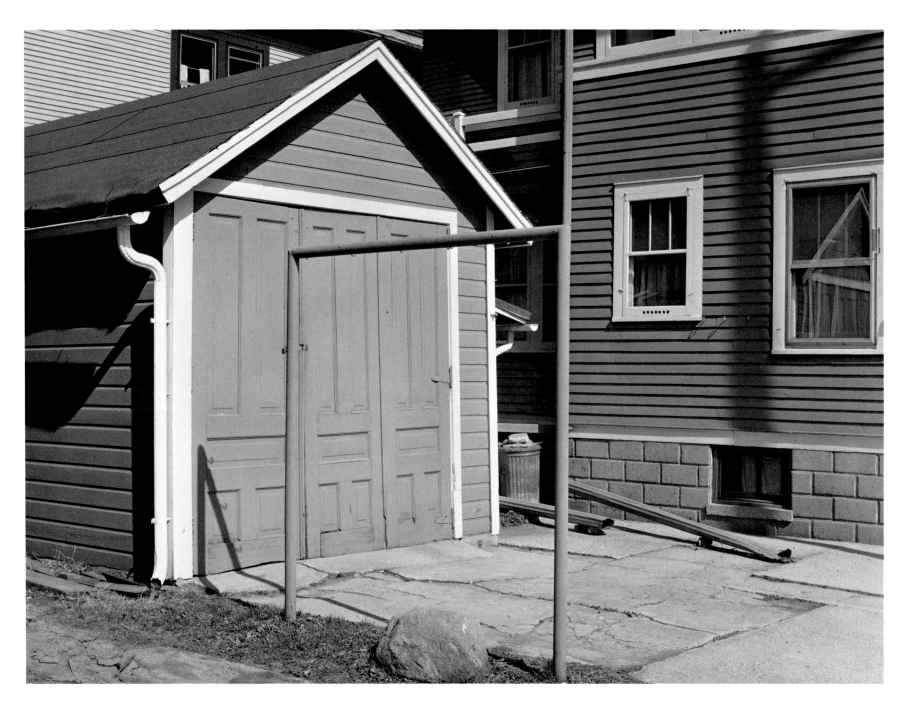

8

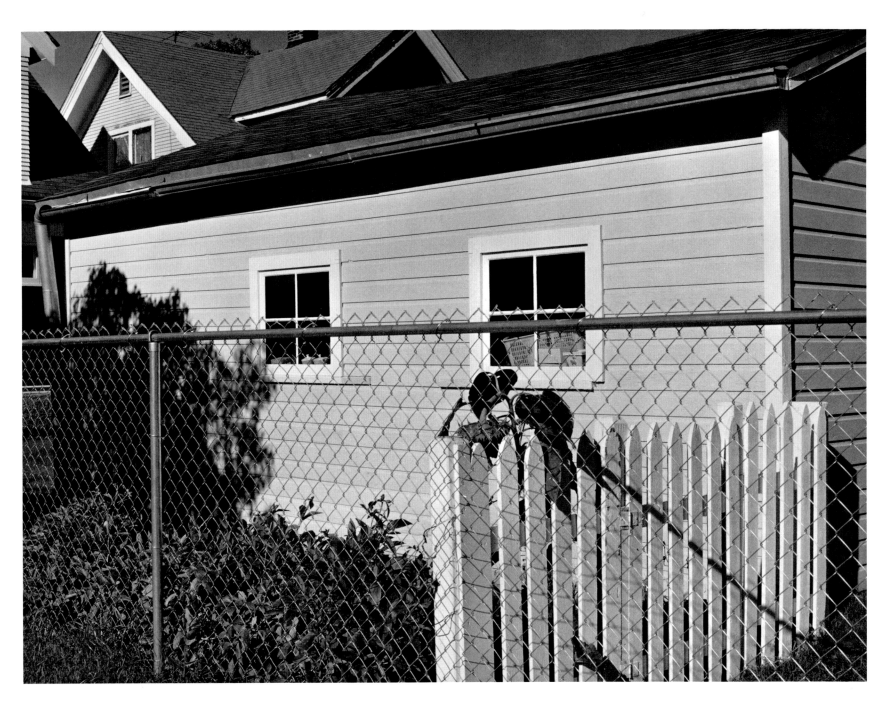

9

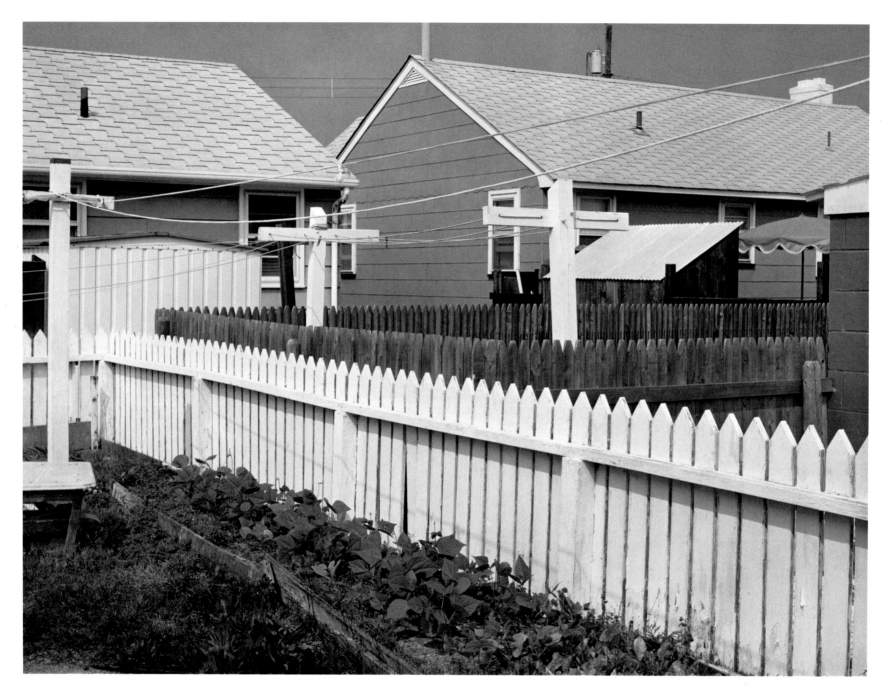

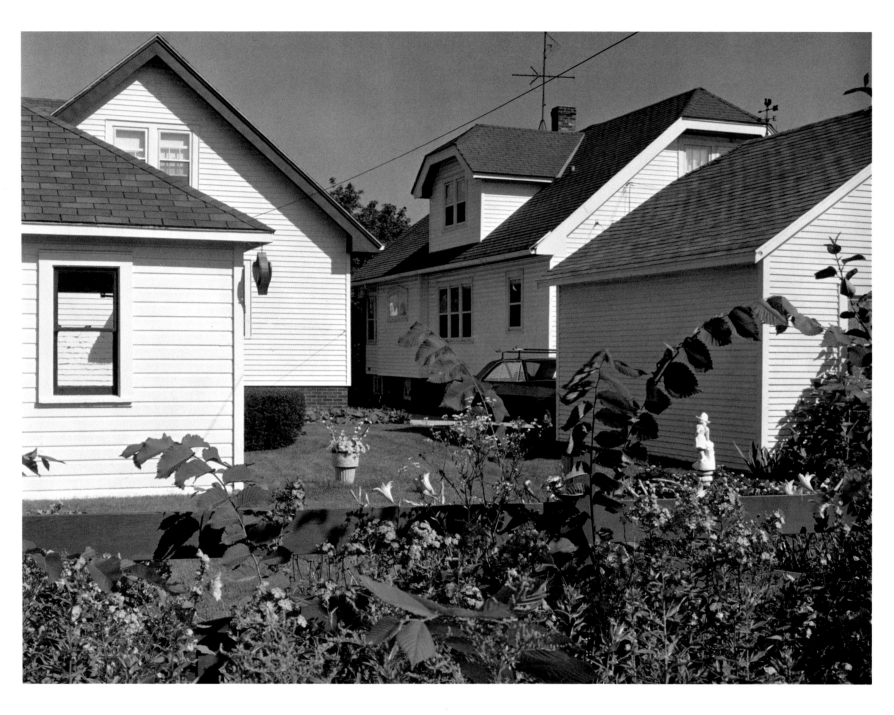

11

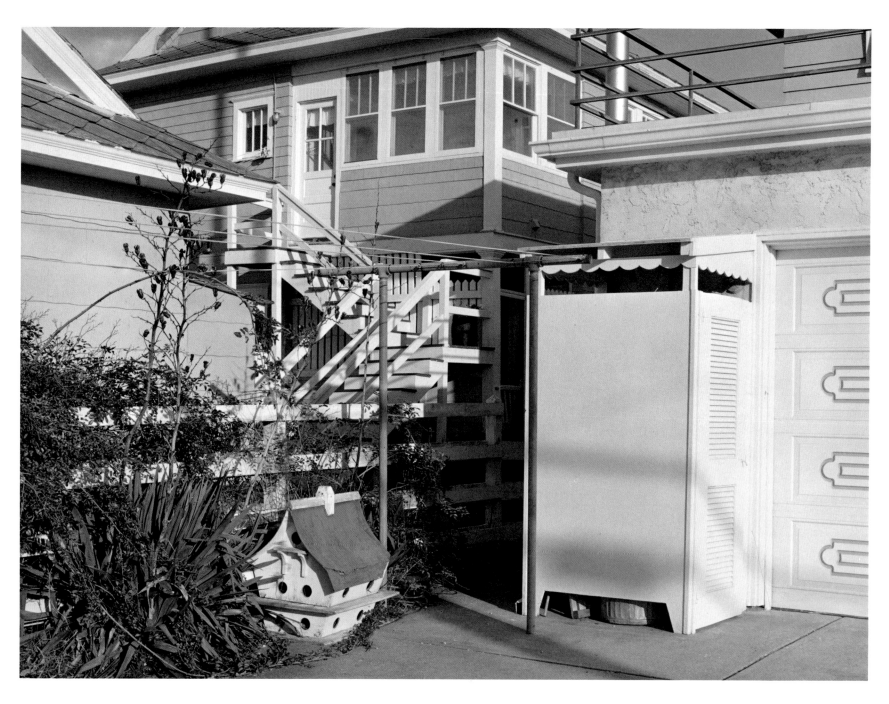

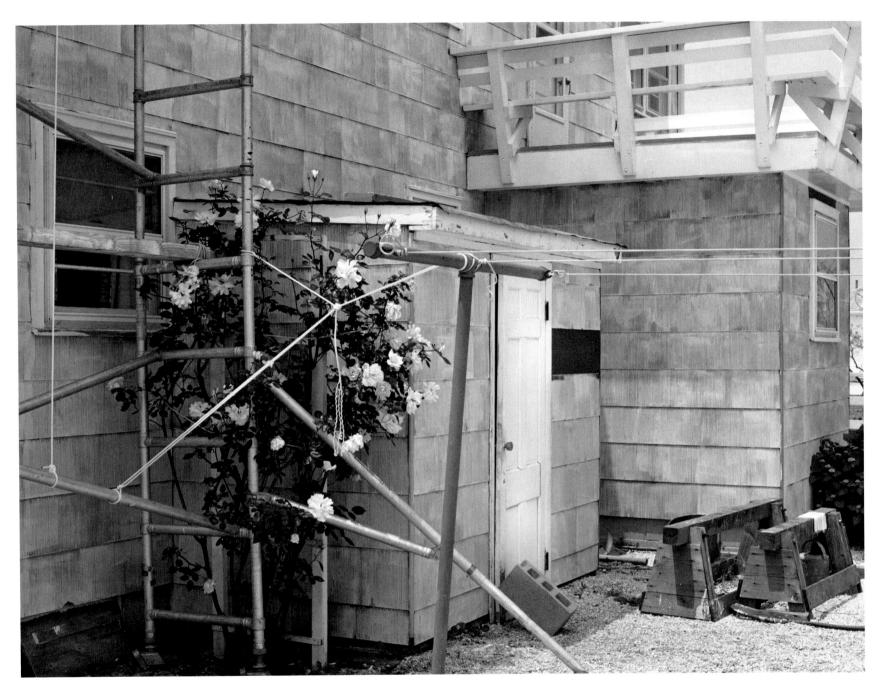

13

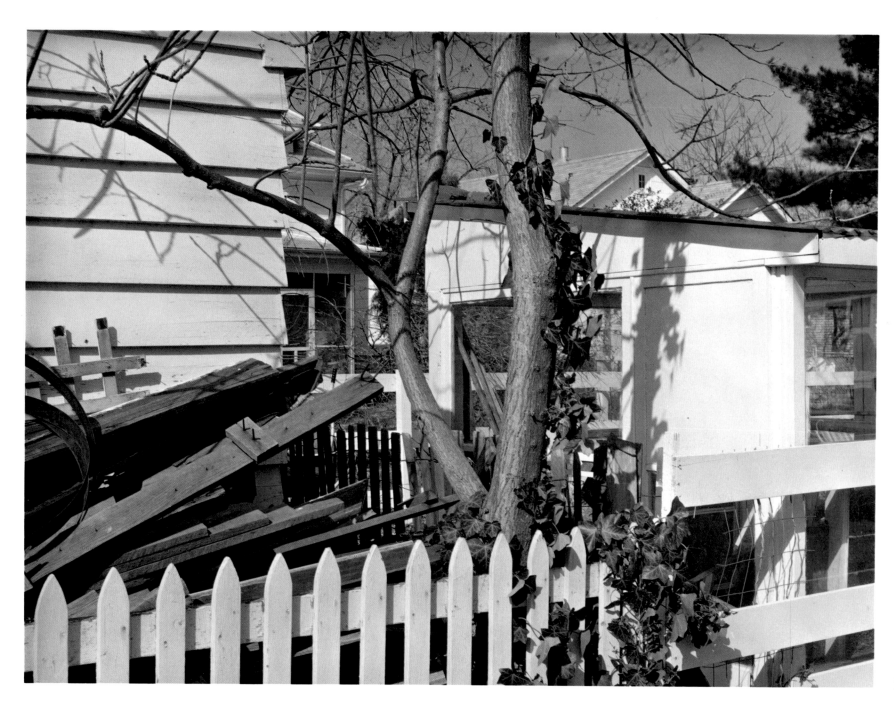

14

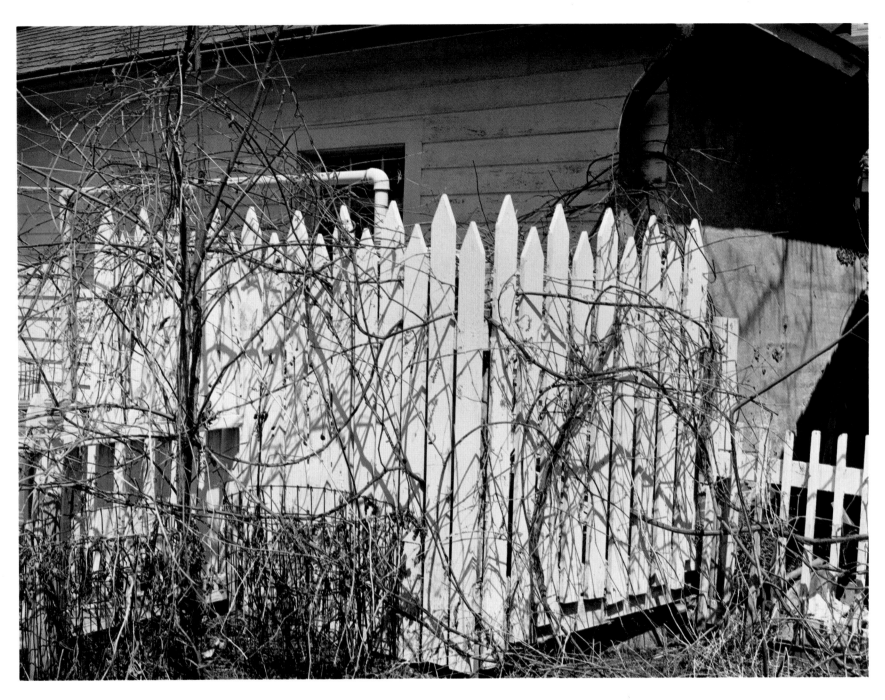

15

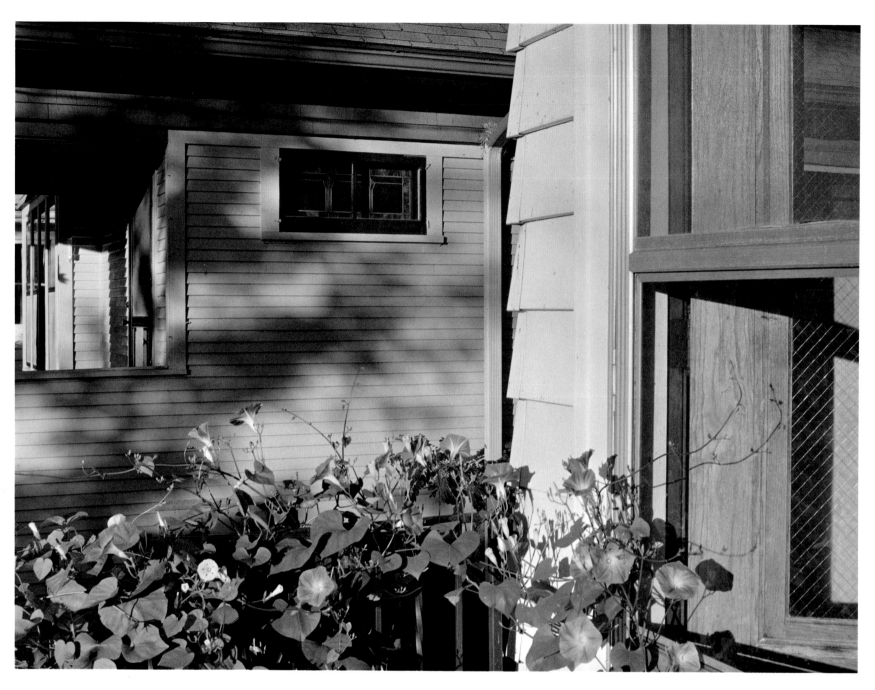

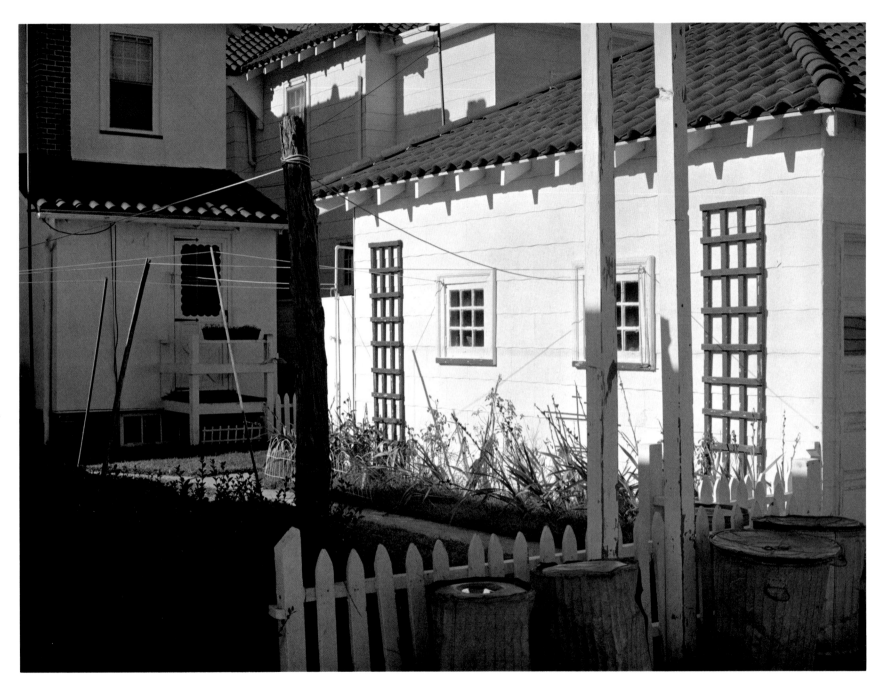

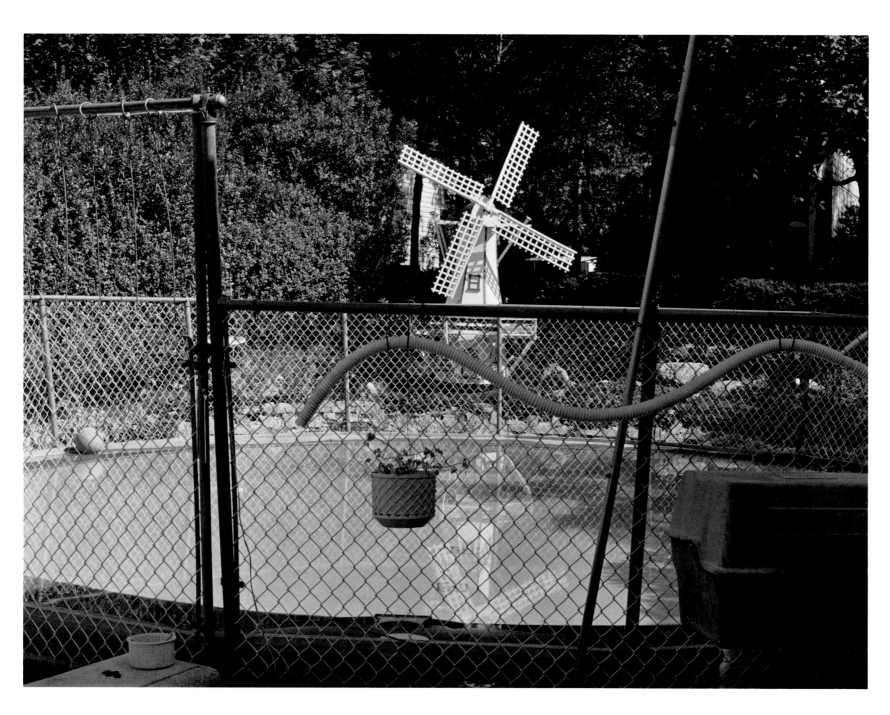

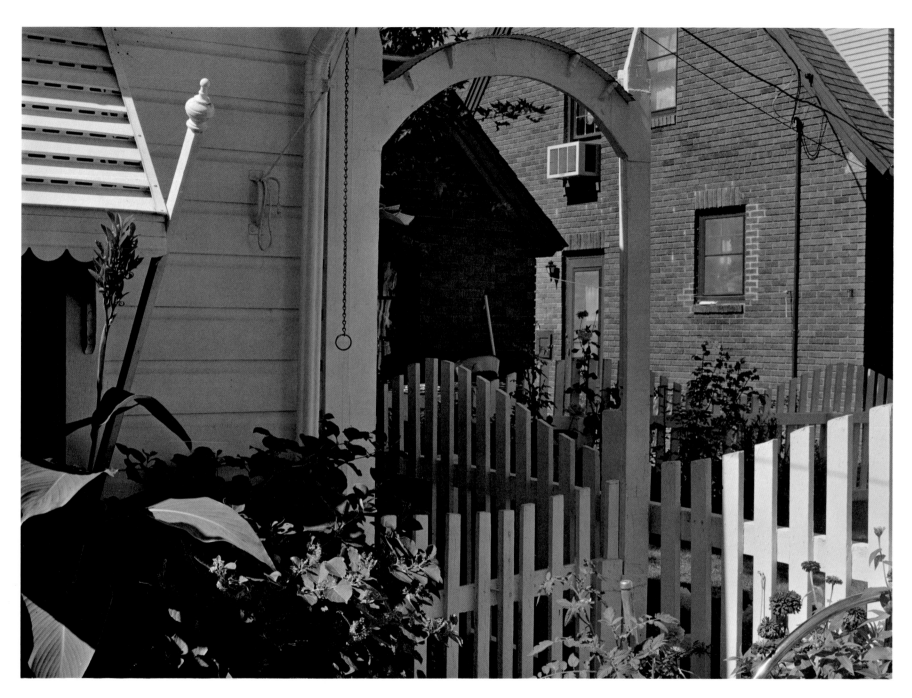

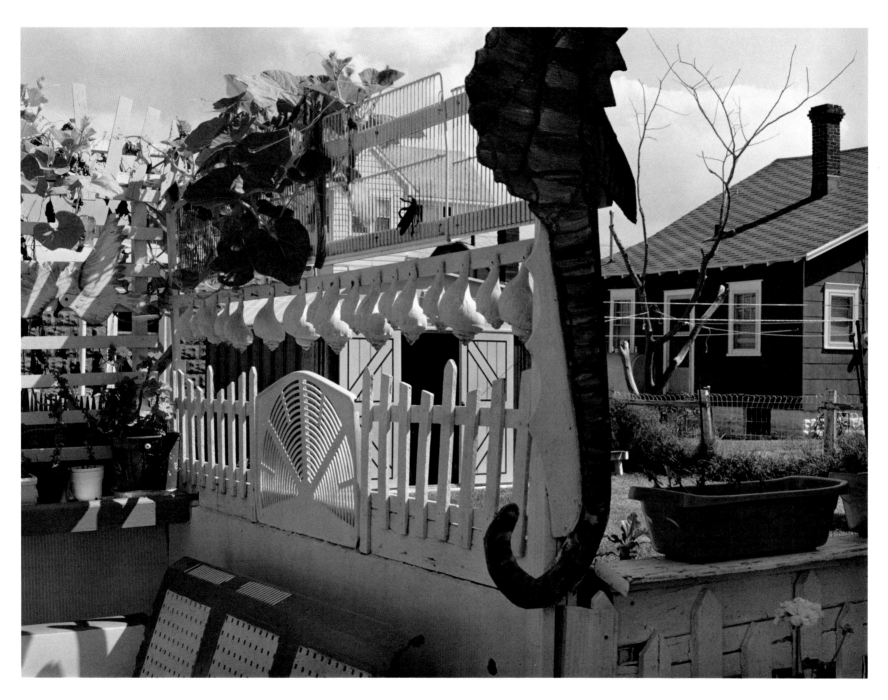

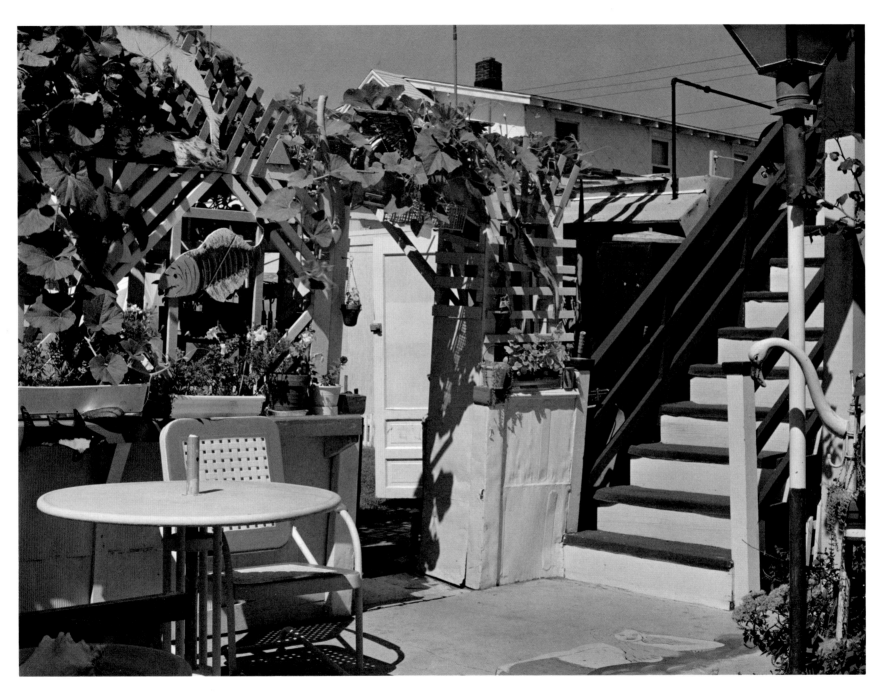

21

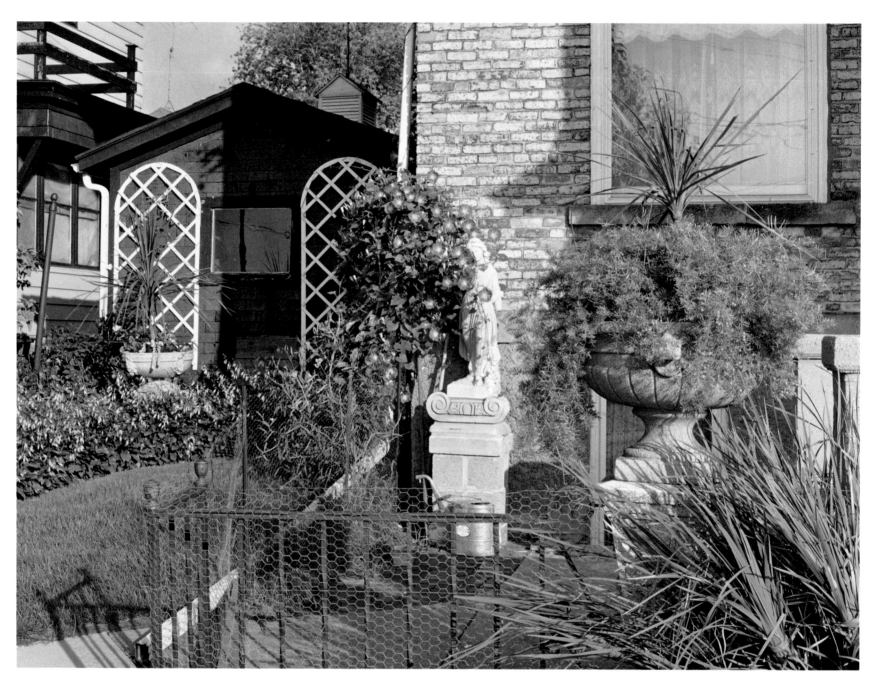

22

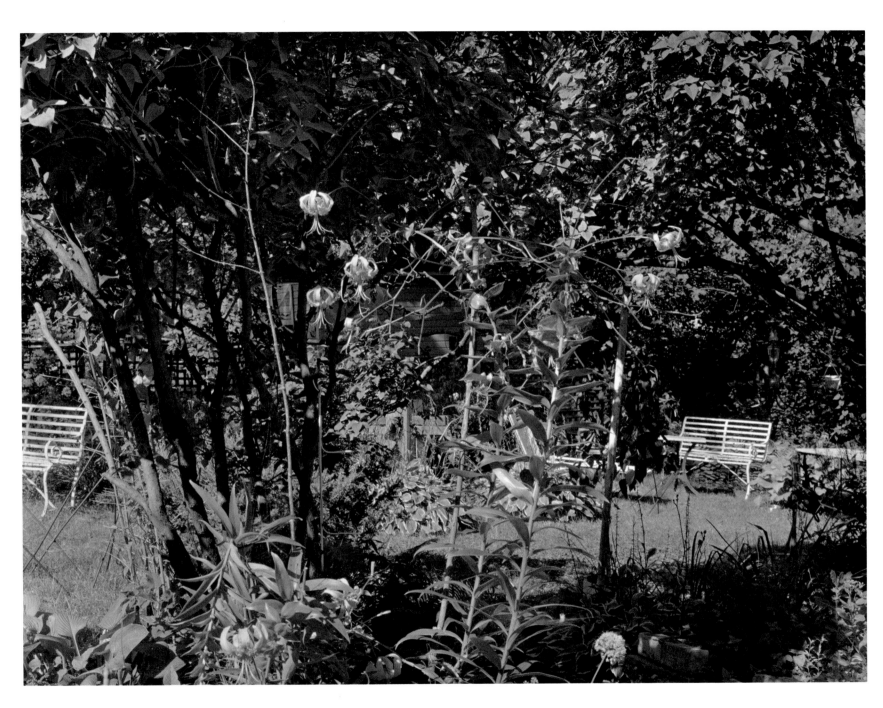

23

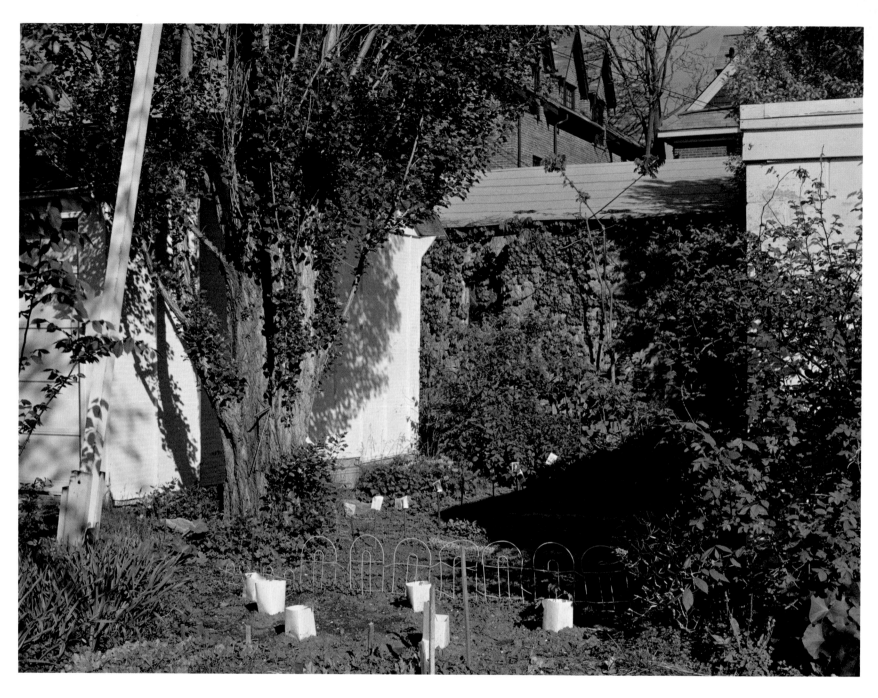

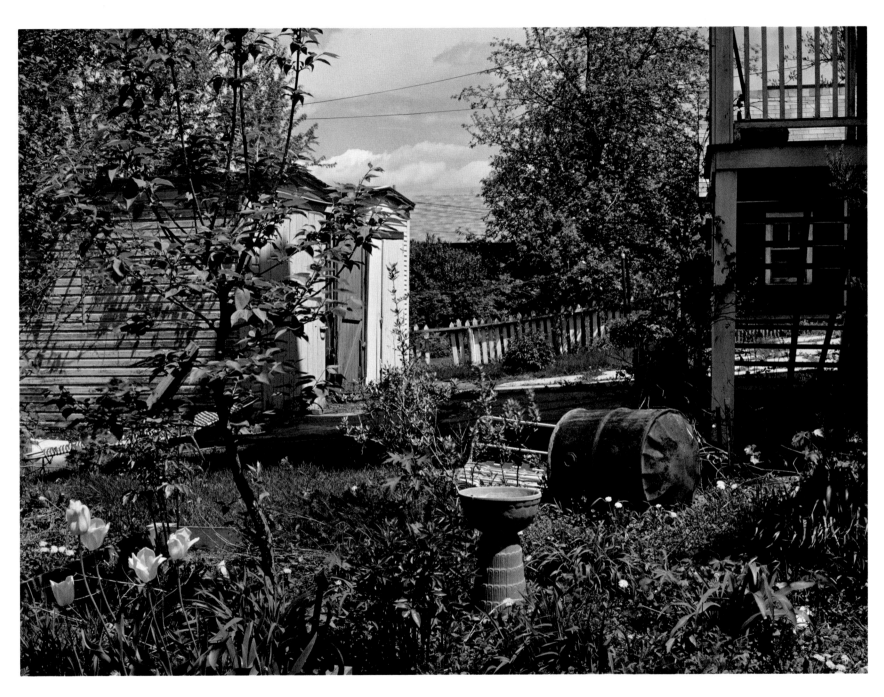

25

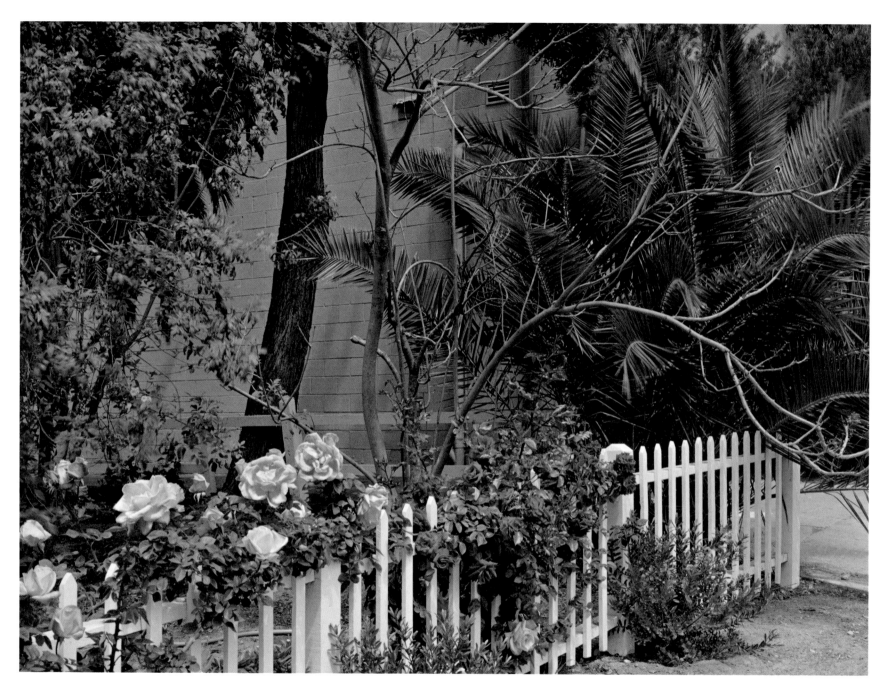

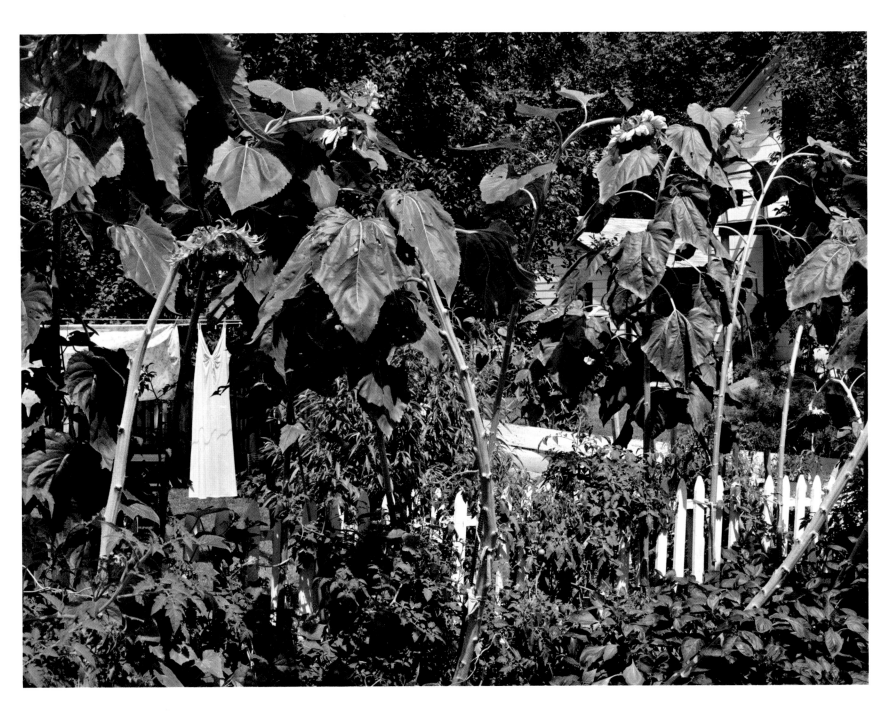

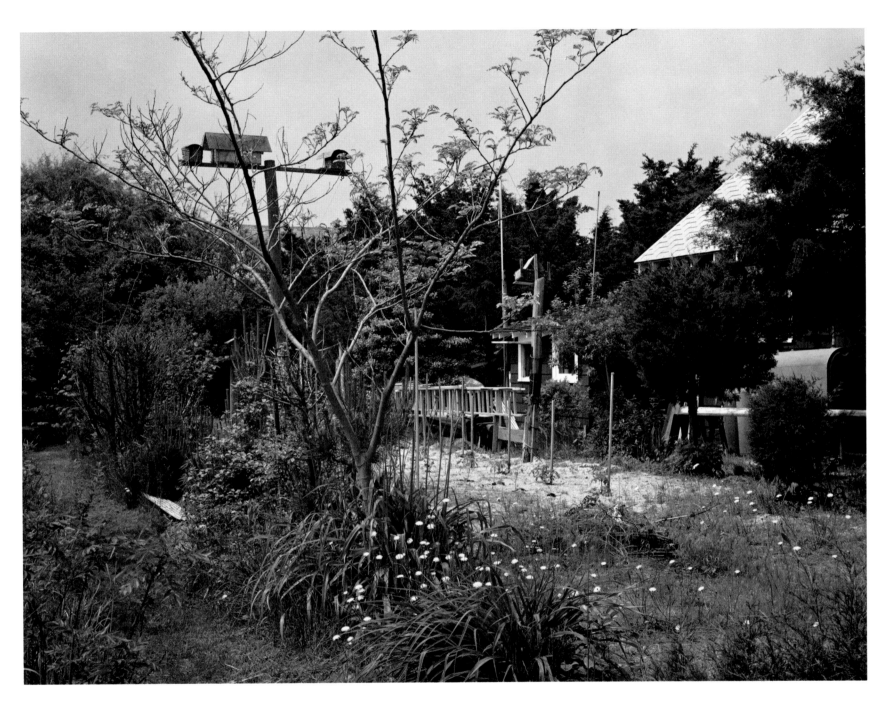

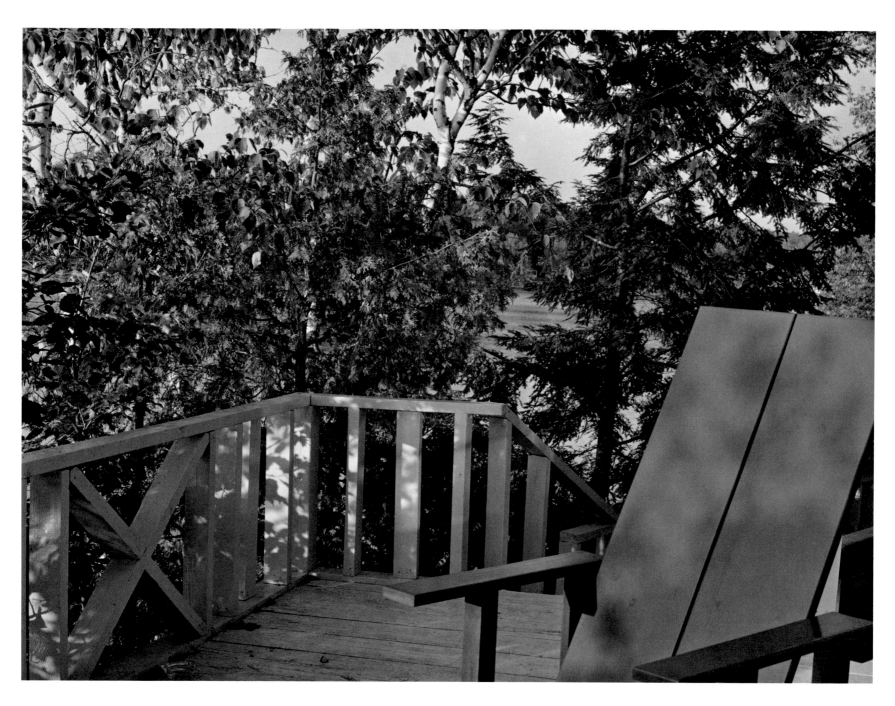

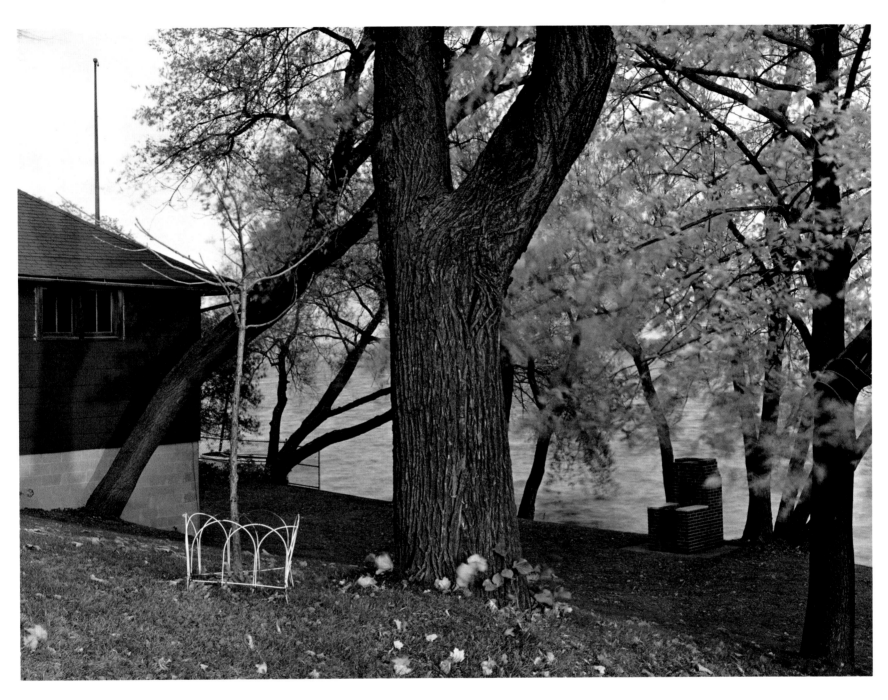

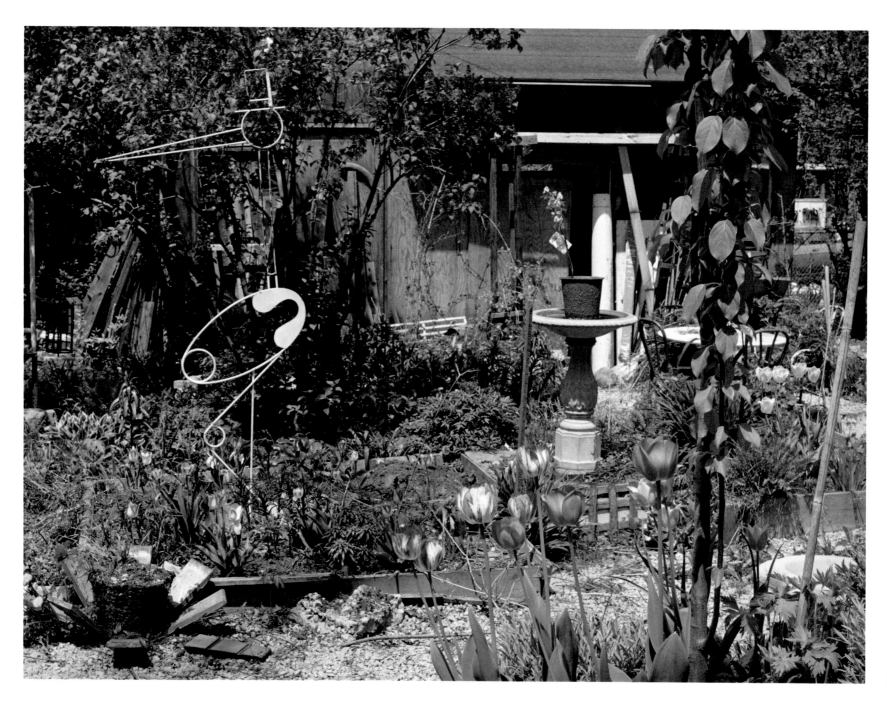

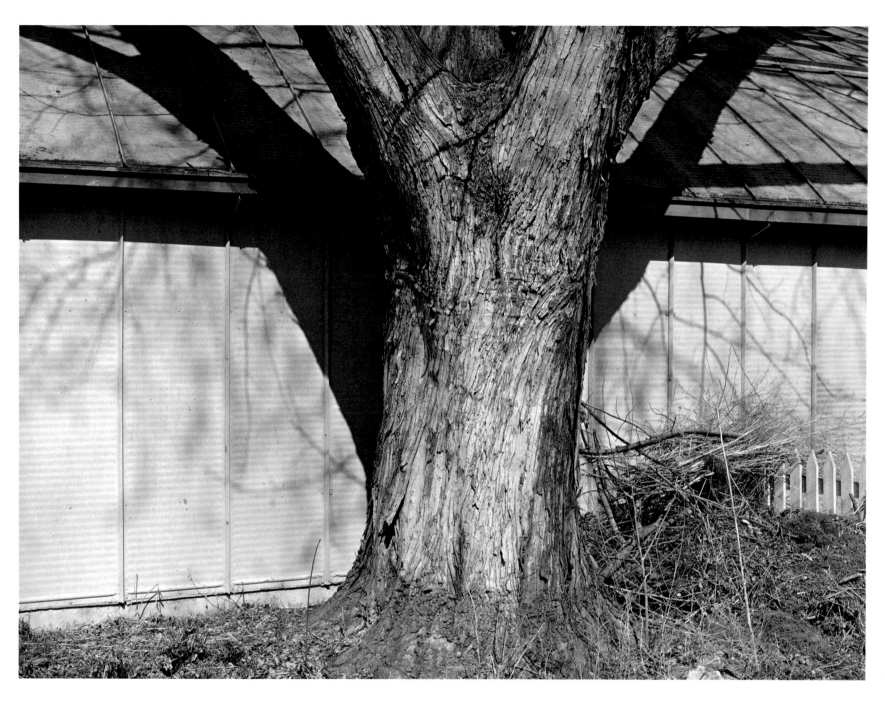

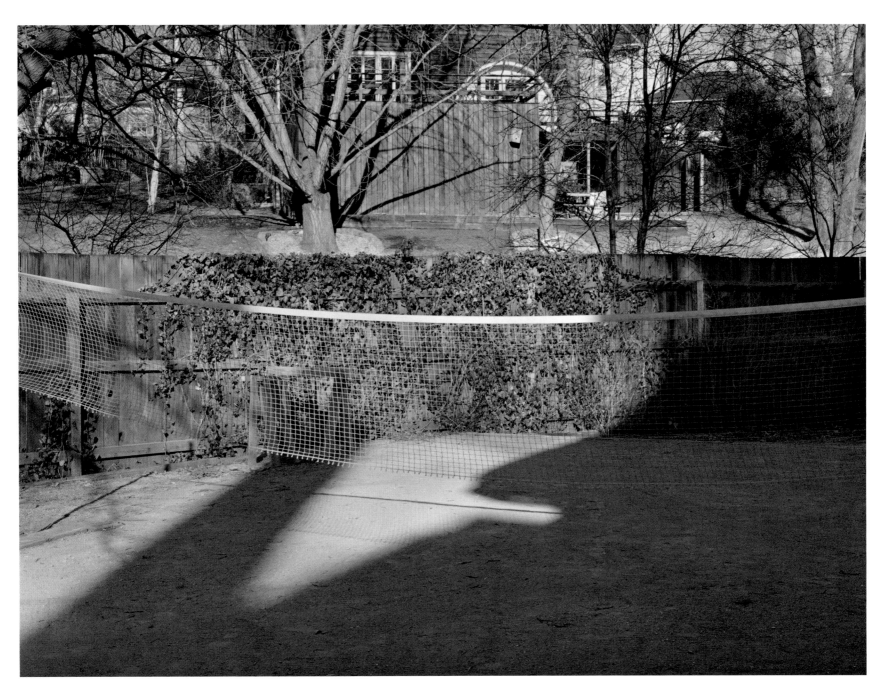

33

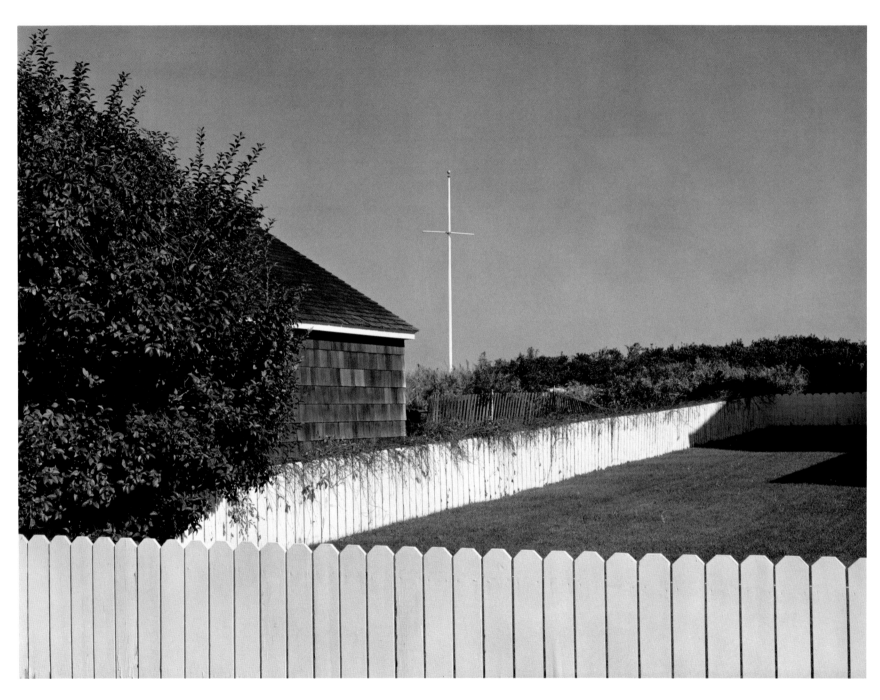

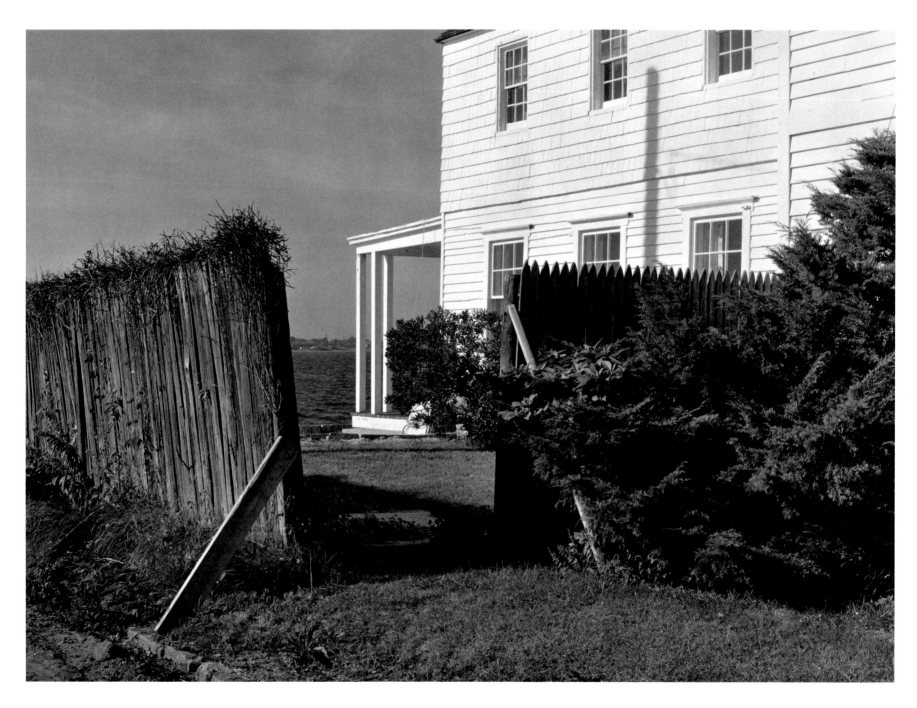

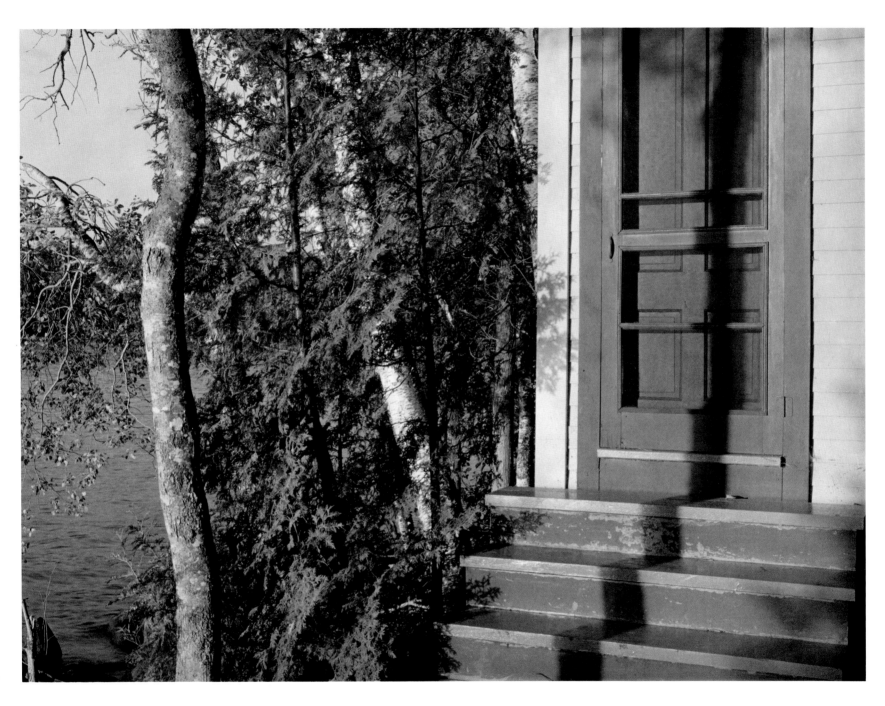

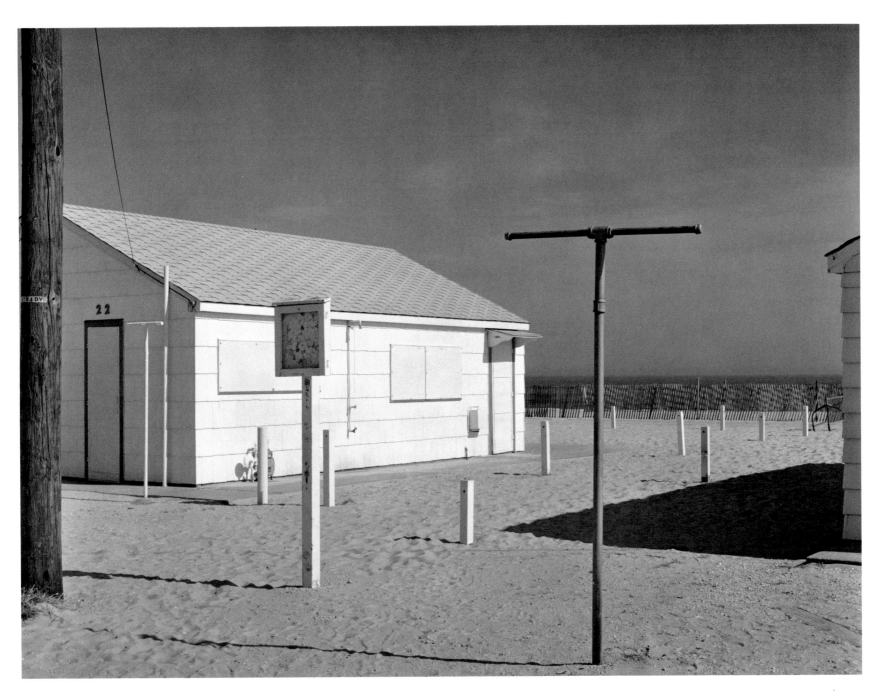

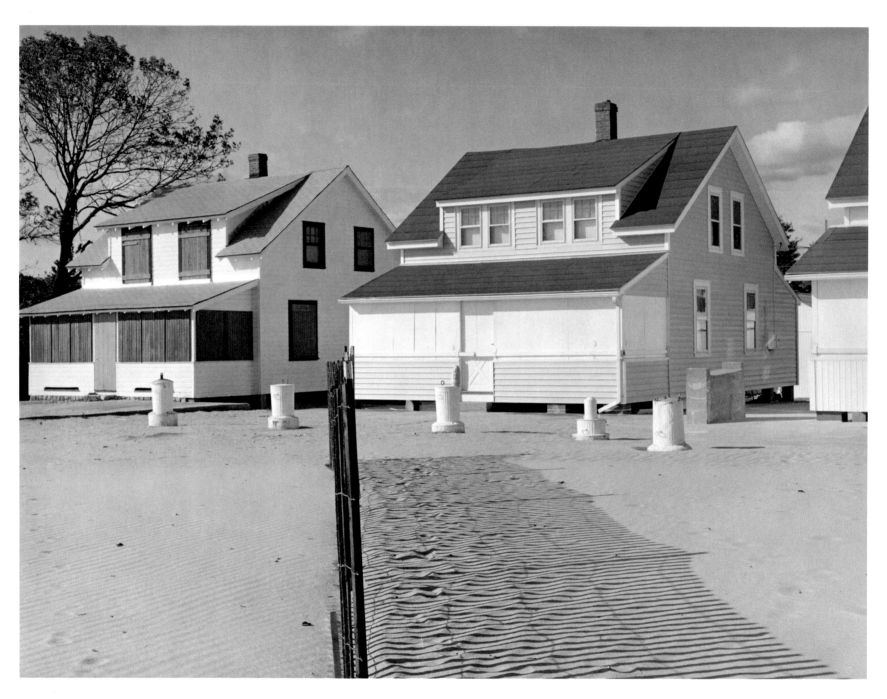

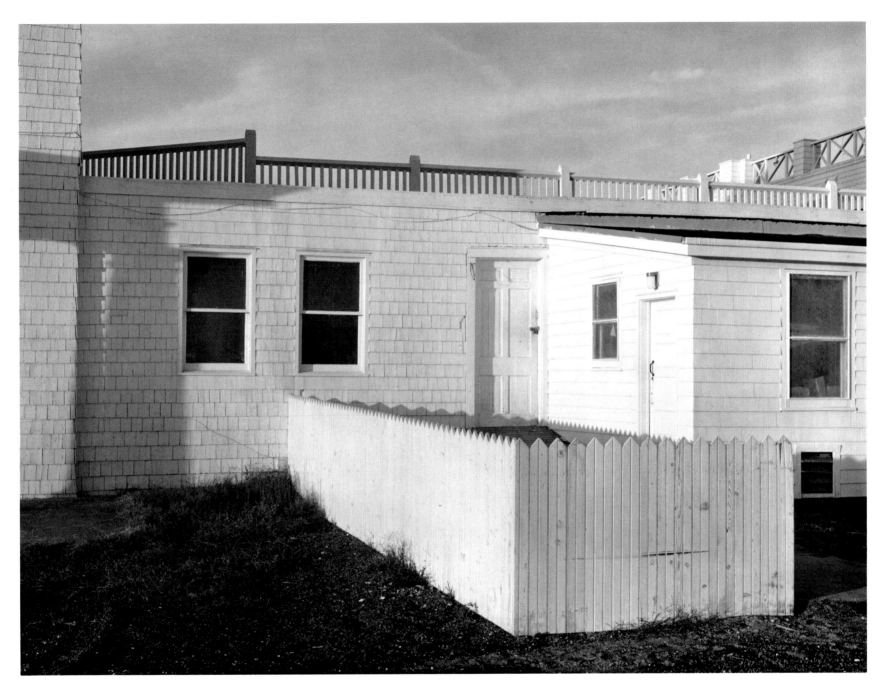

39

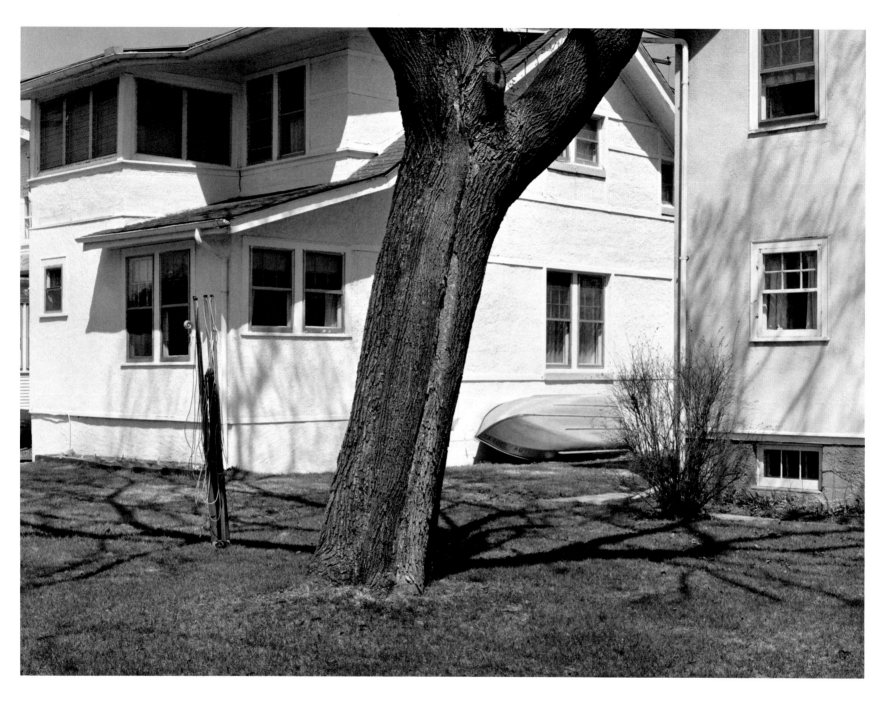

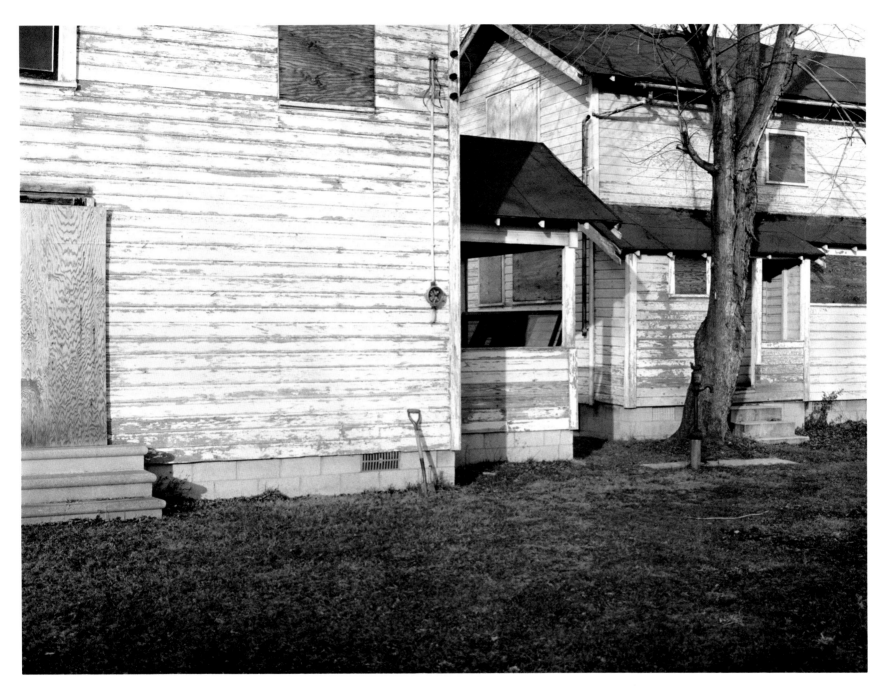

41

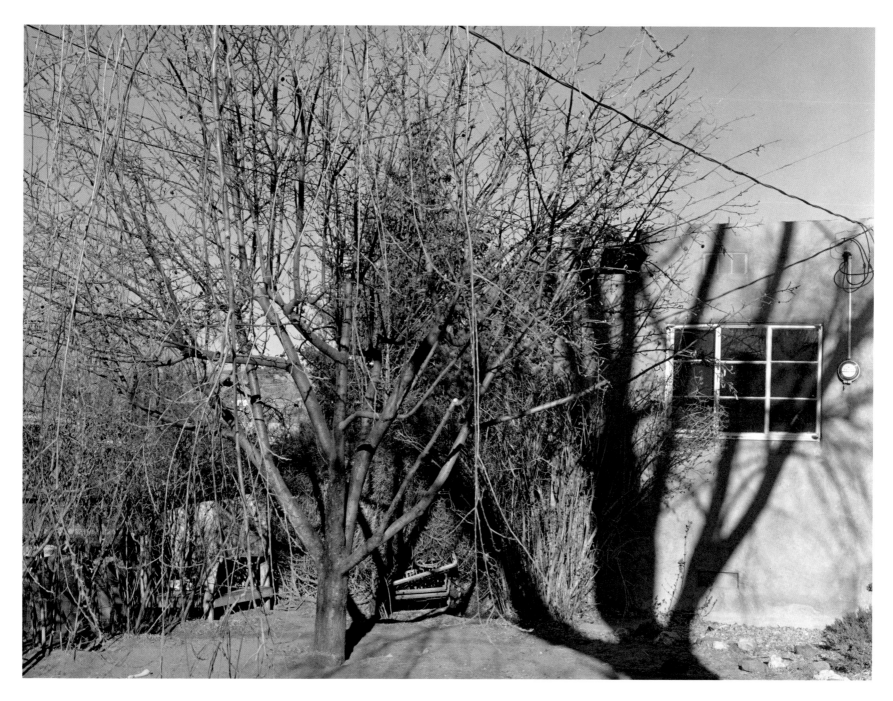

42

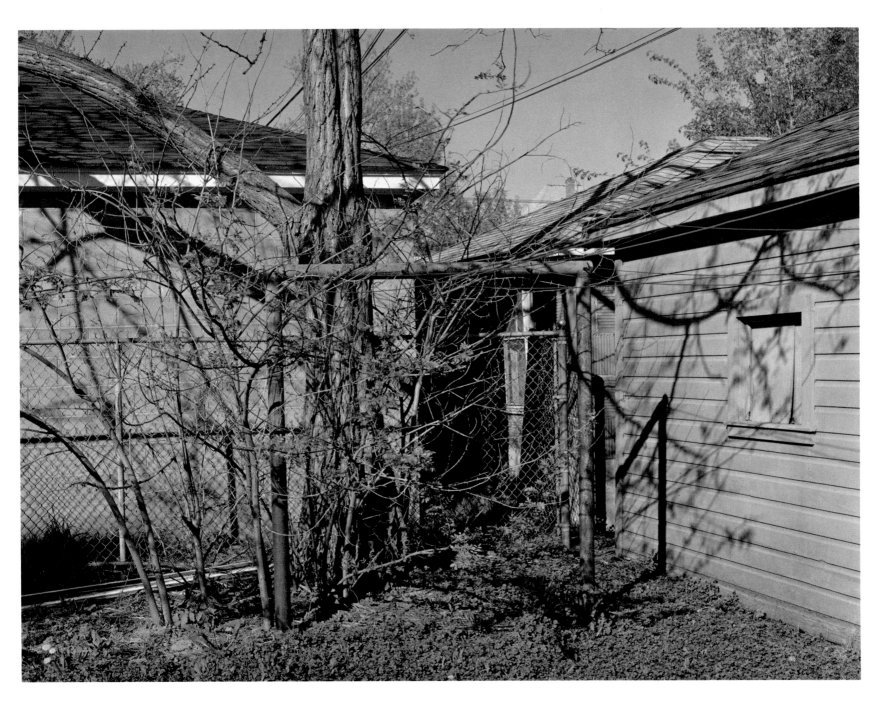

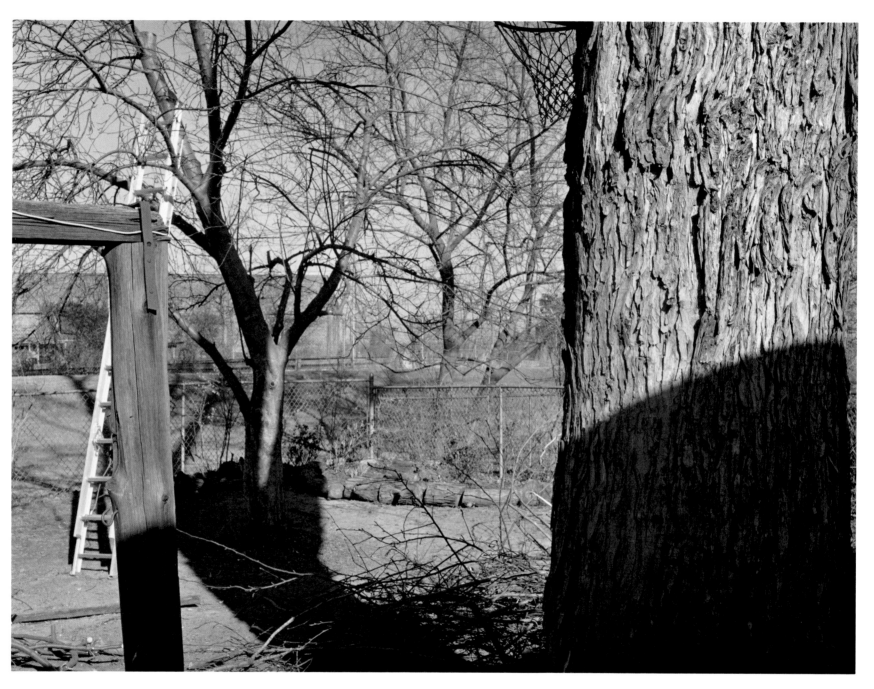

44

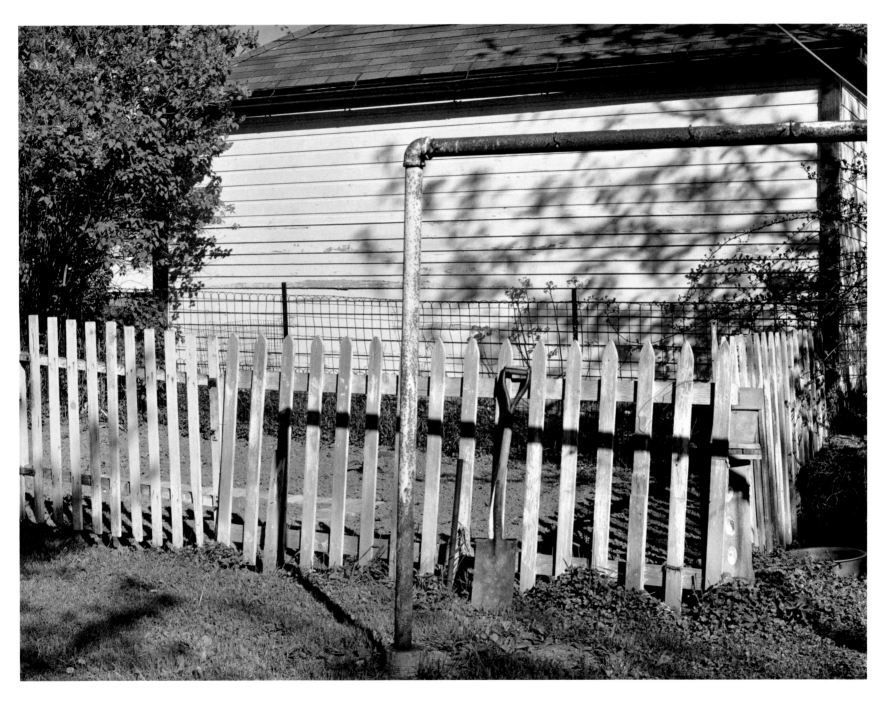

45

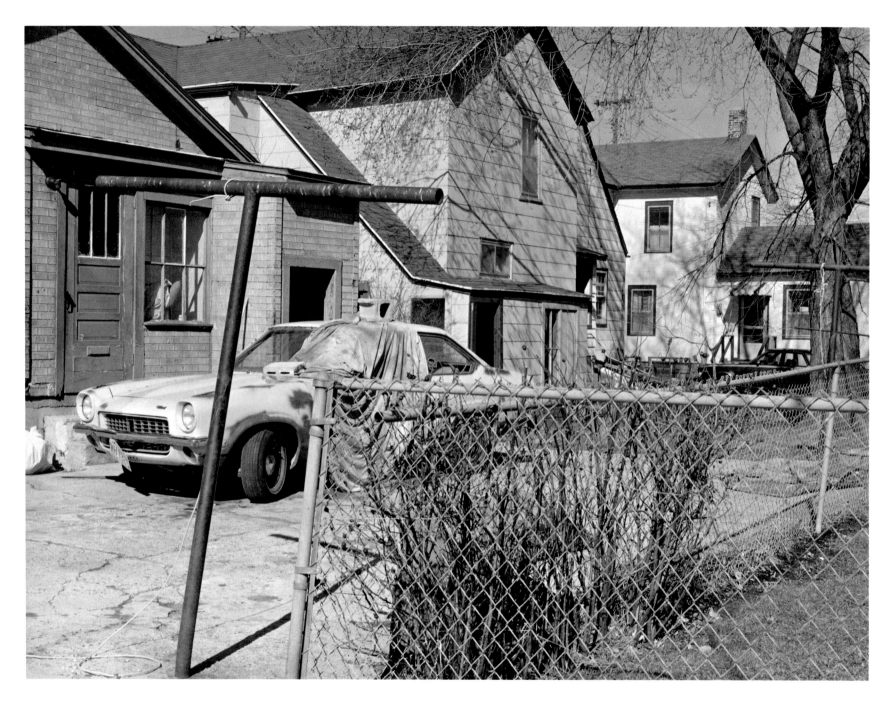

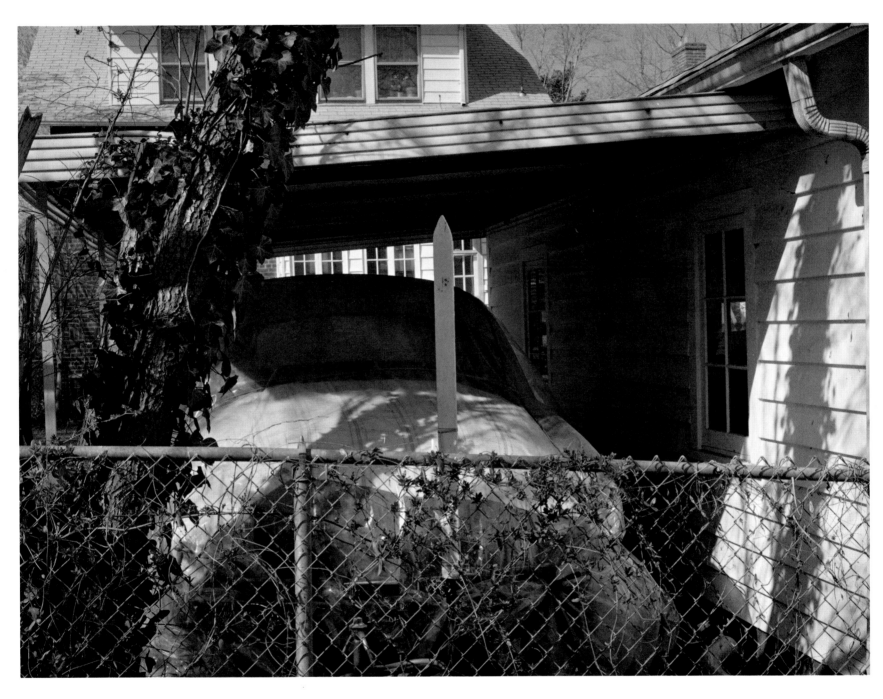

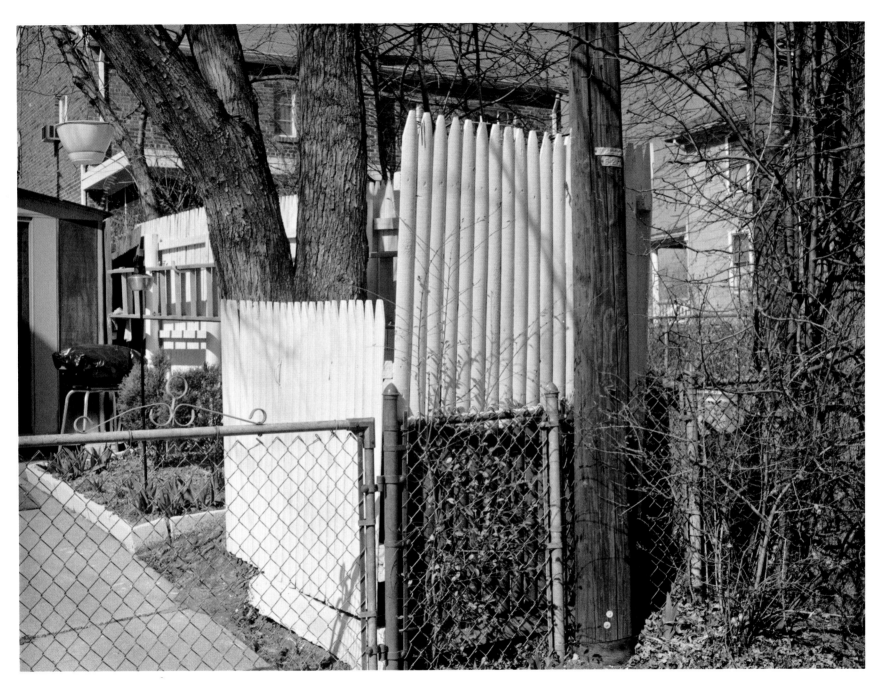

48

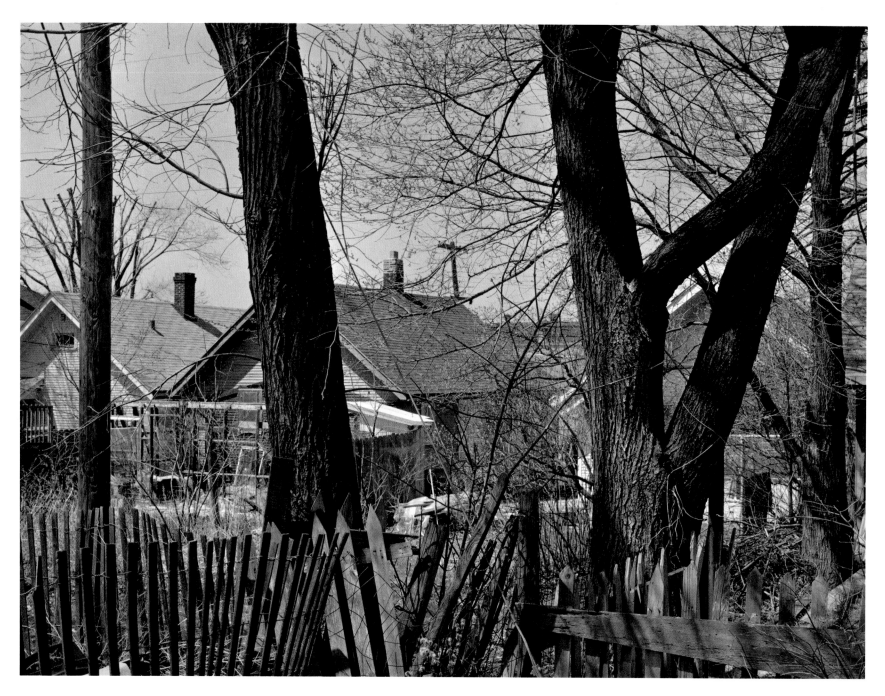

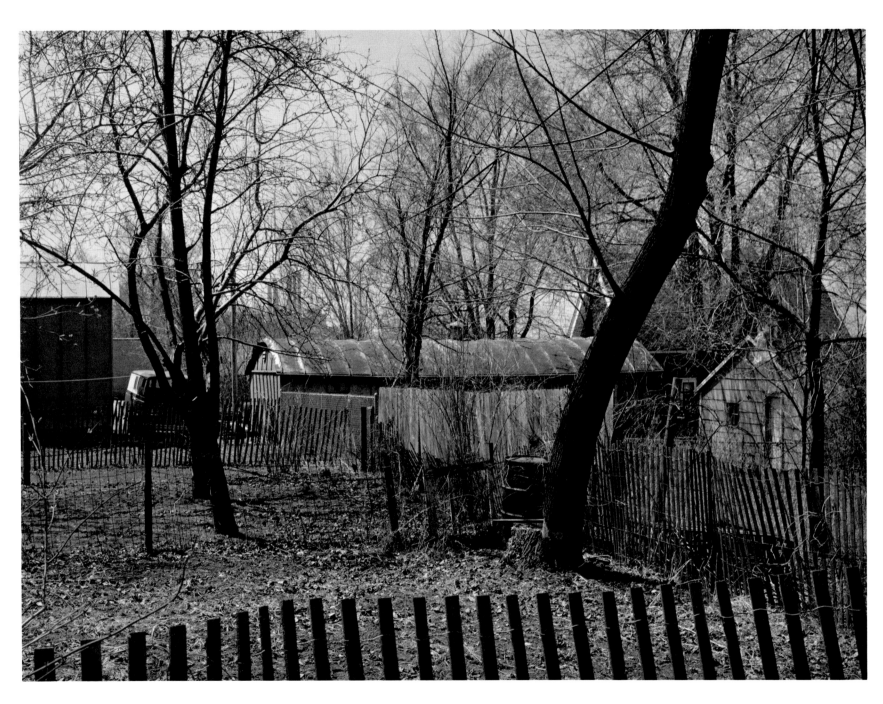

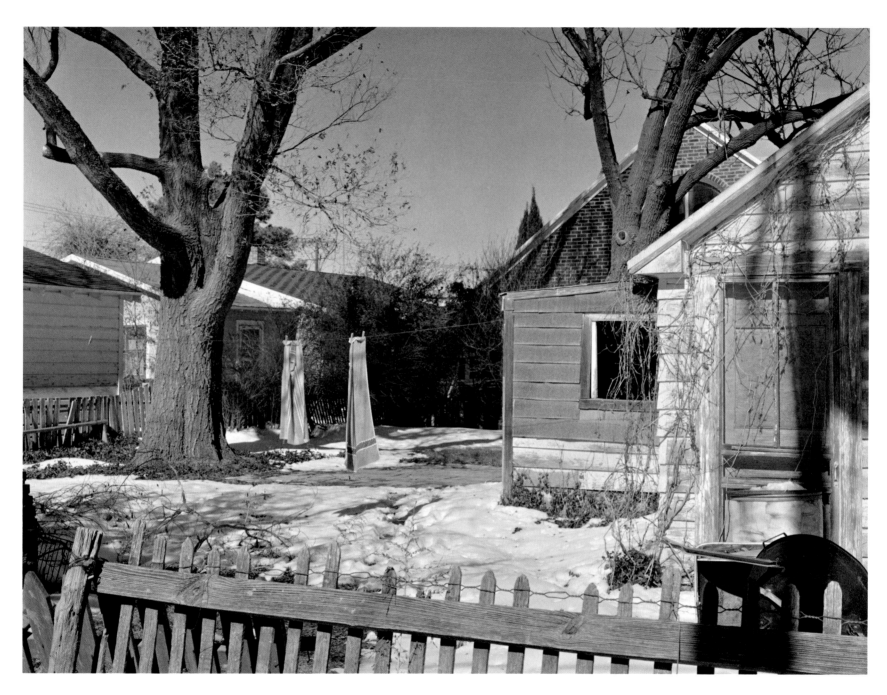

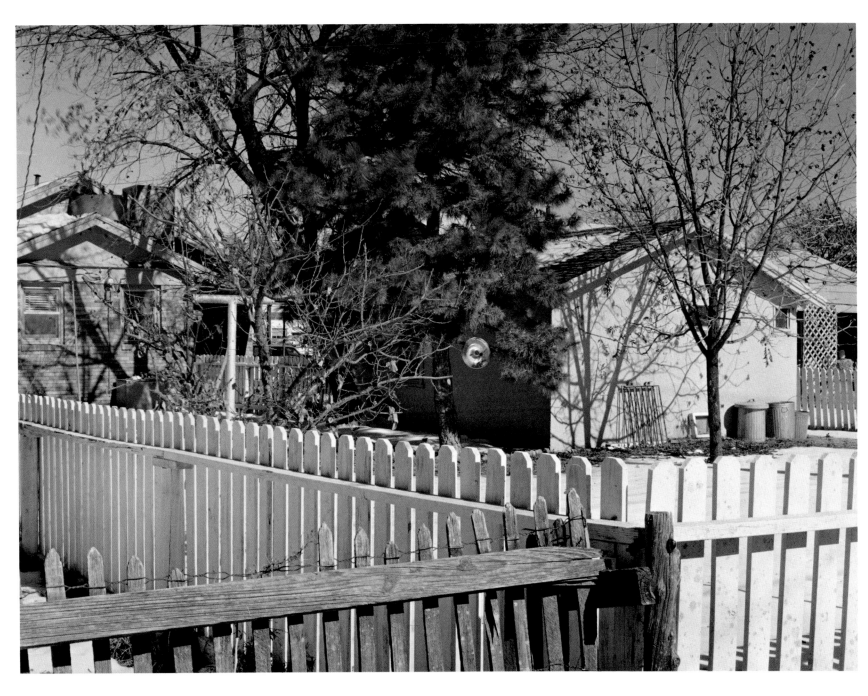

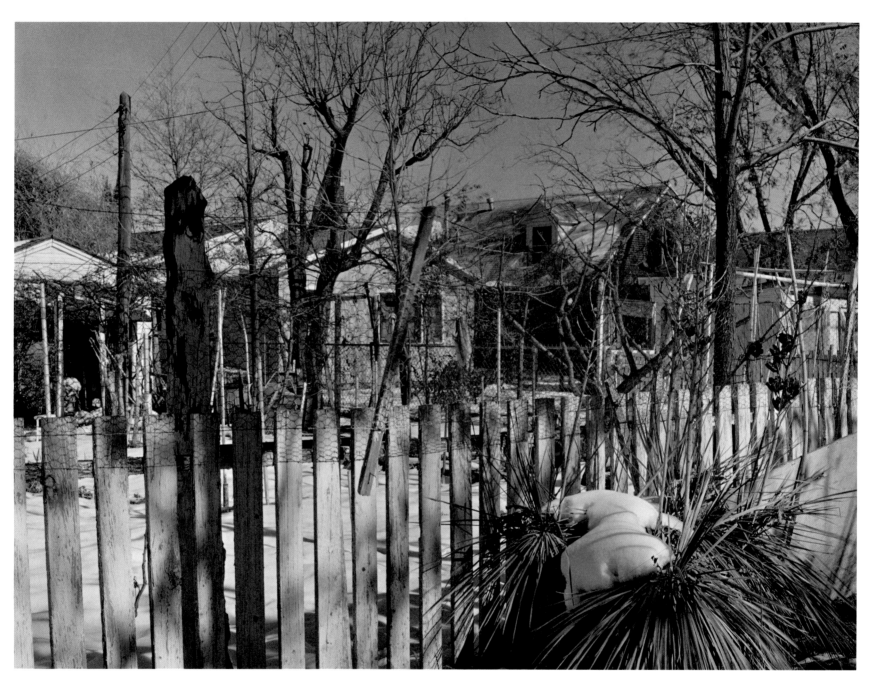

53

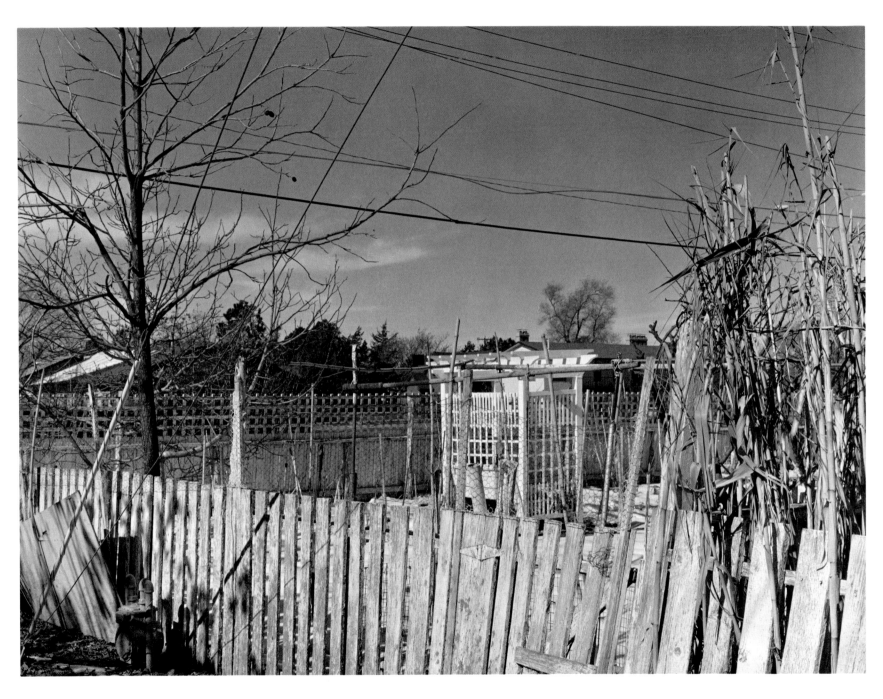

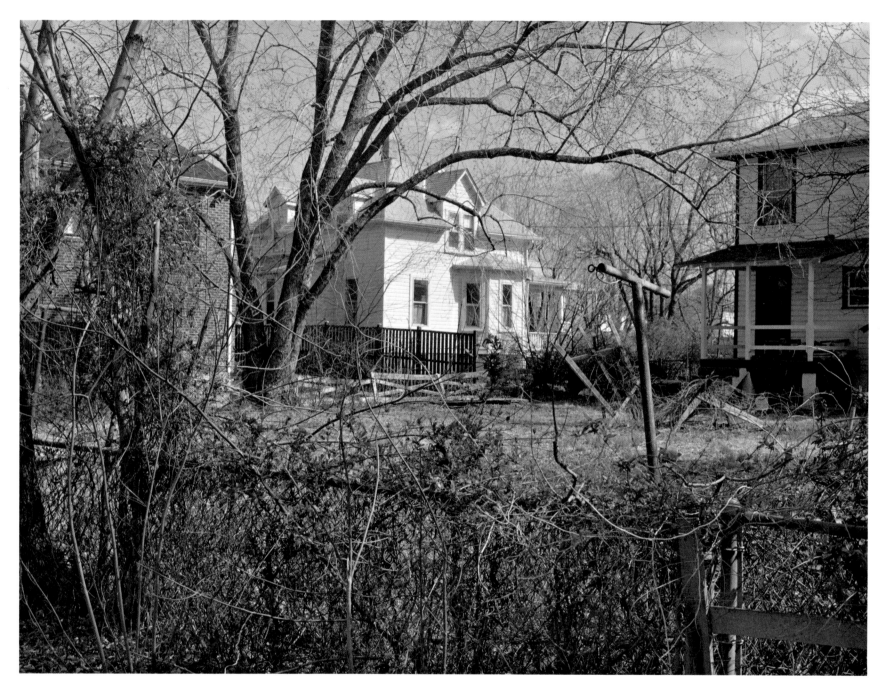

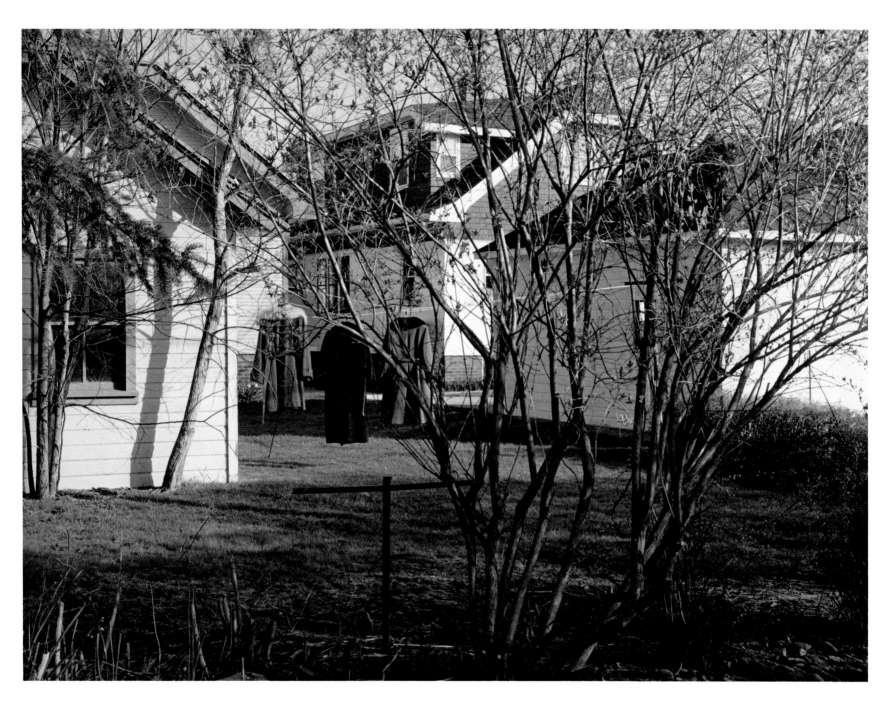

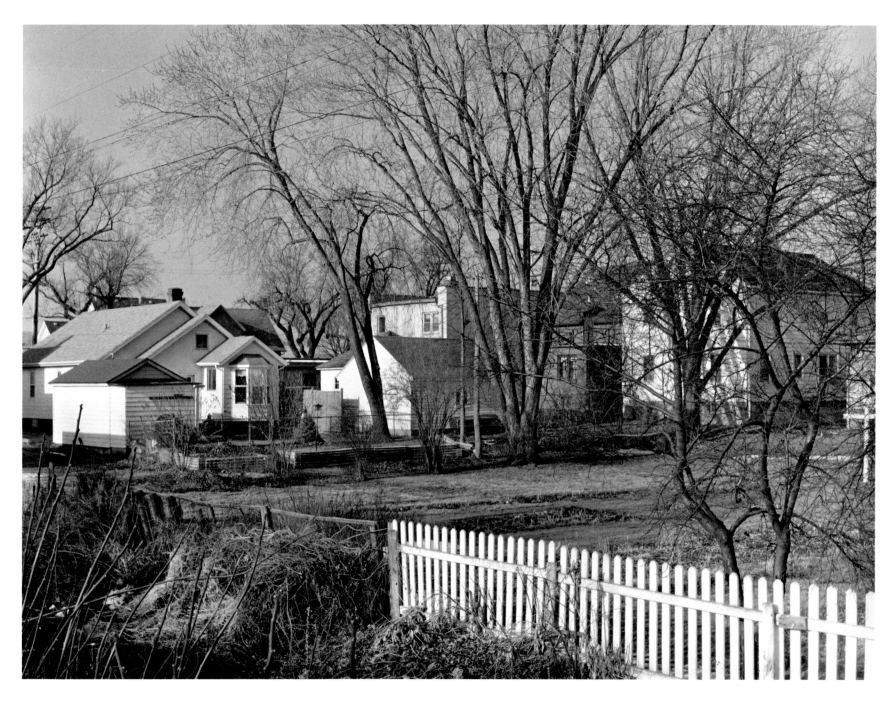

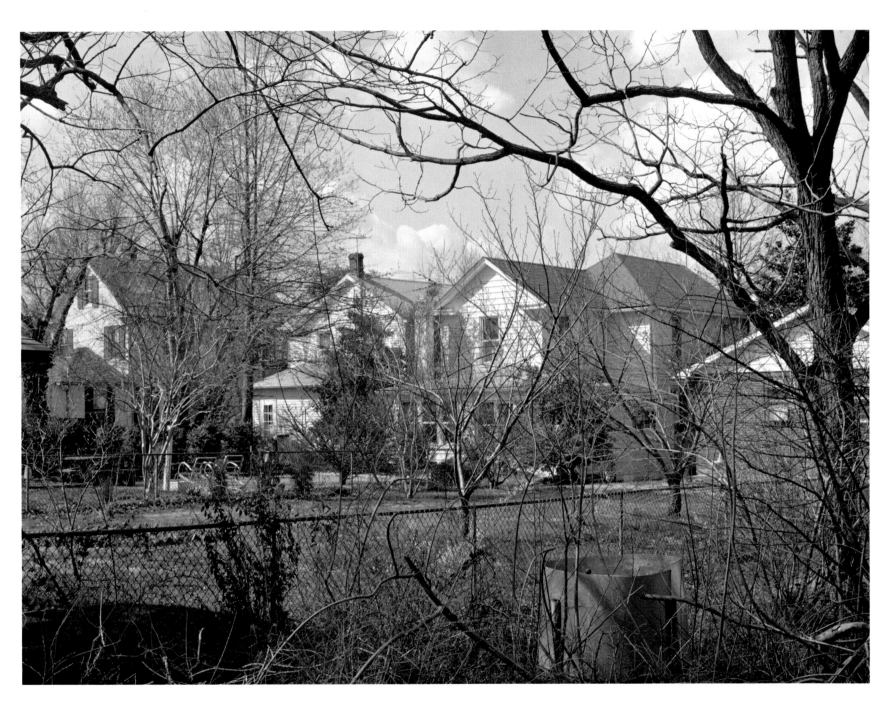

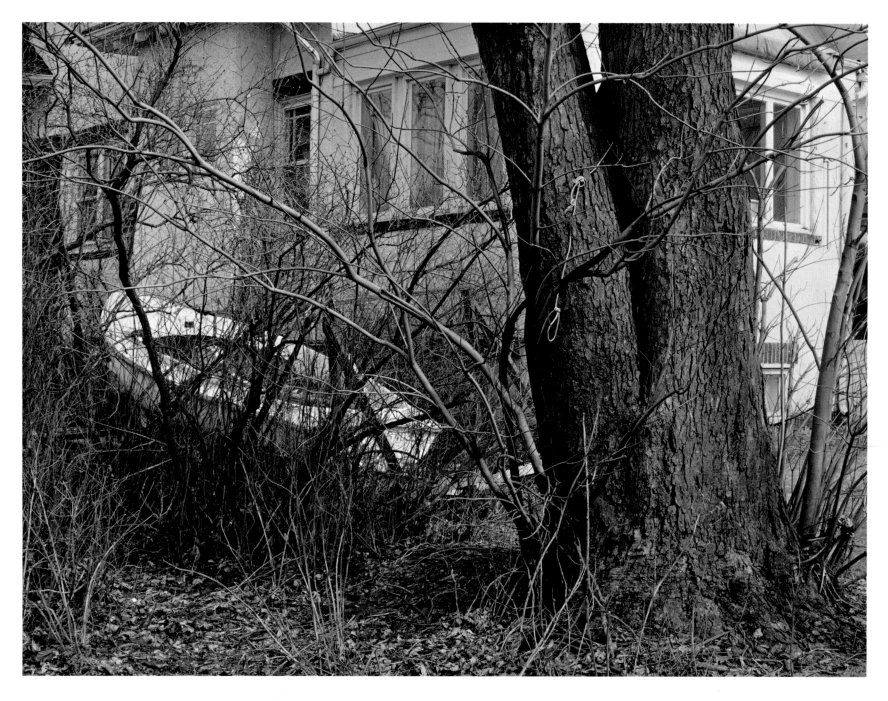

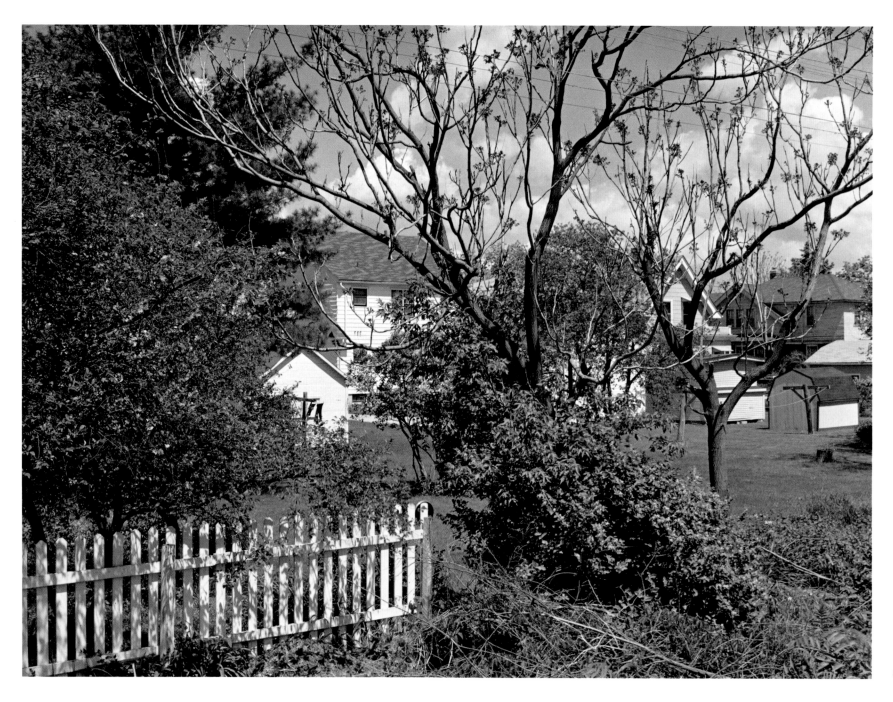

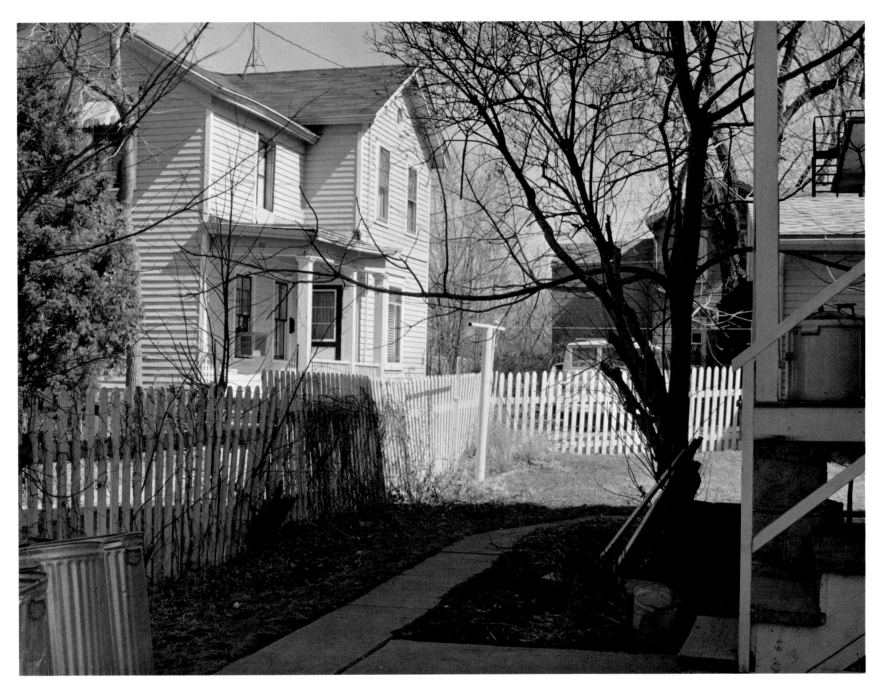

61

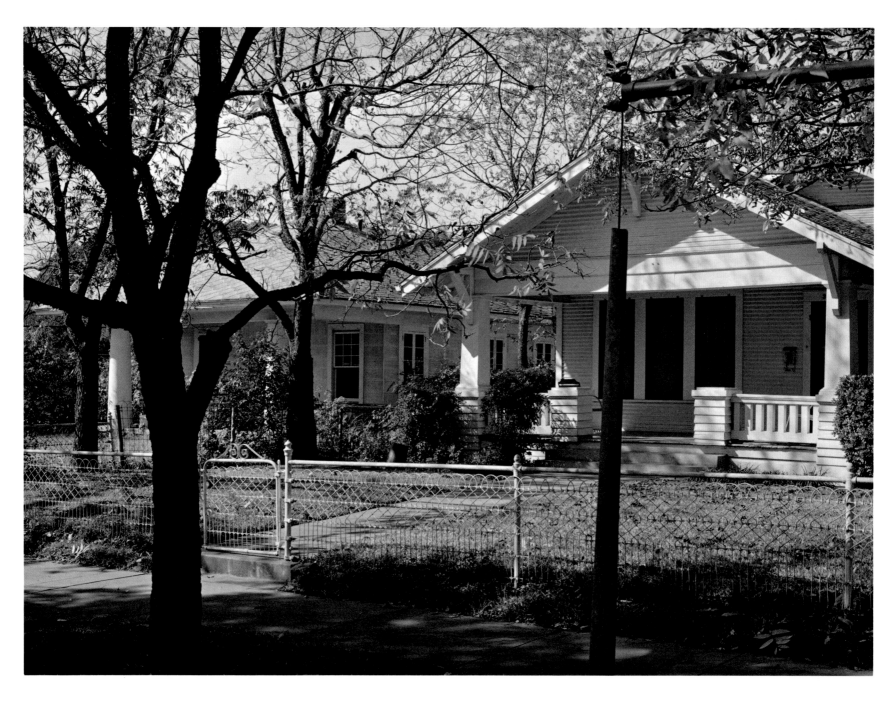

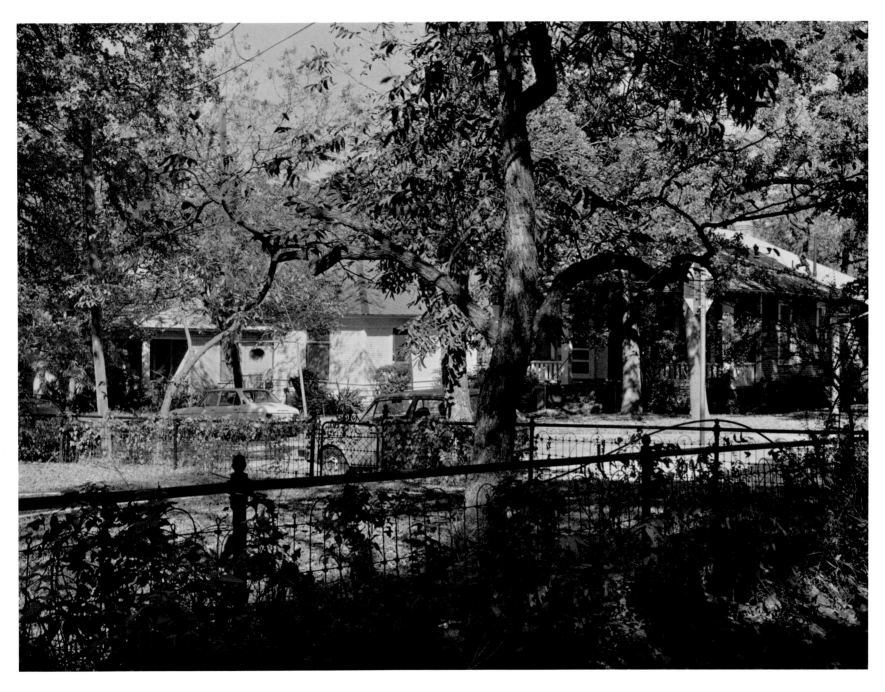

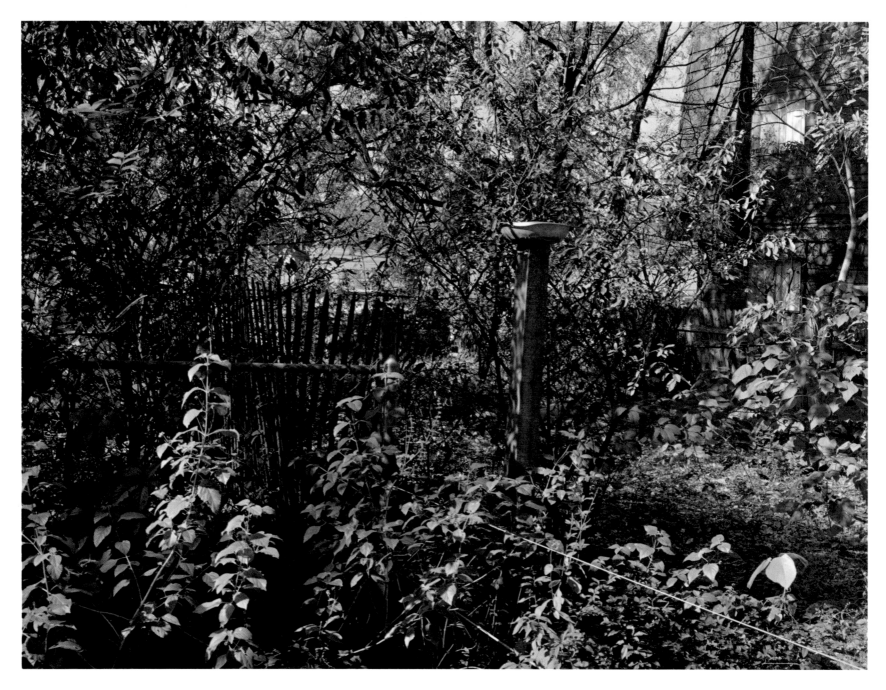

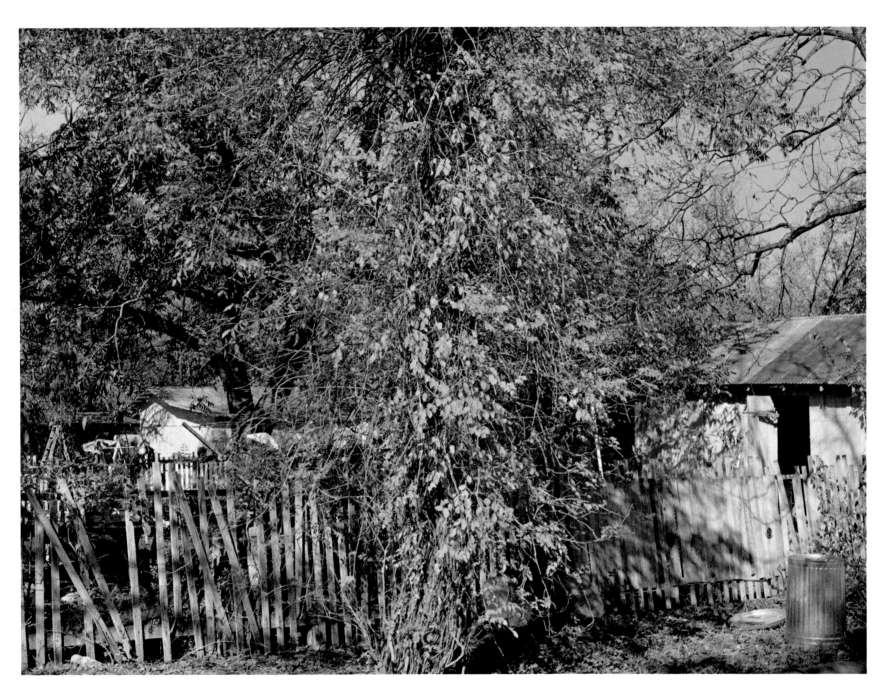

65

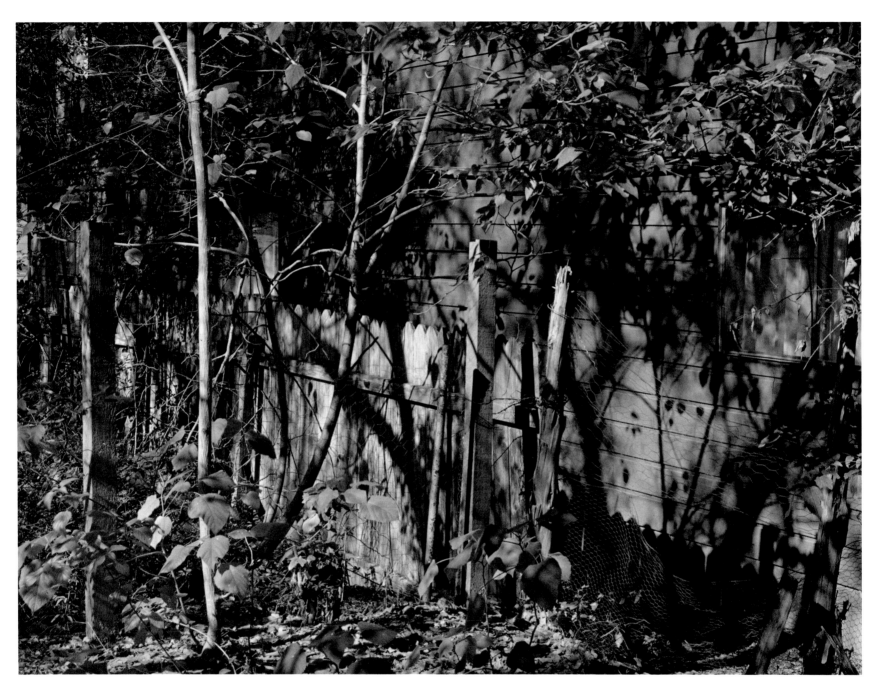

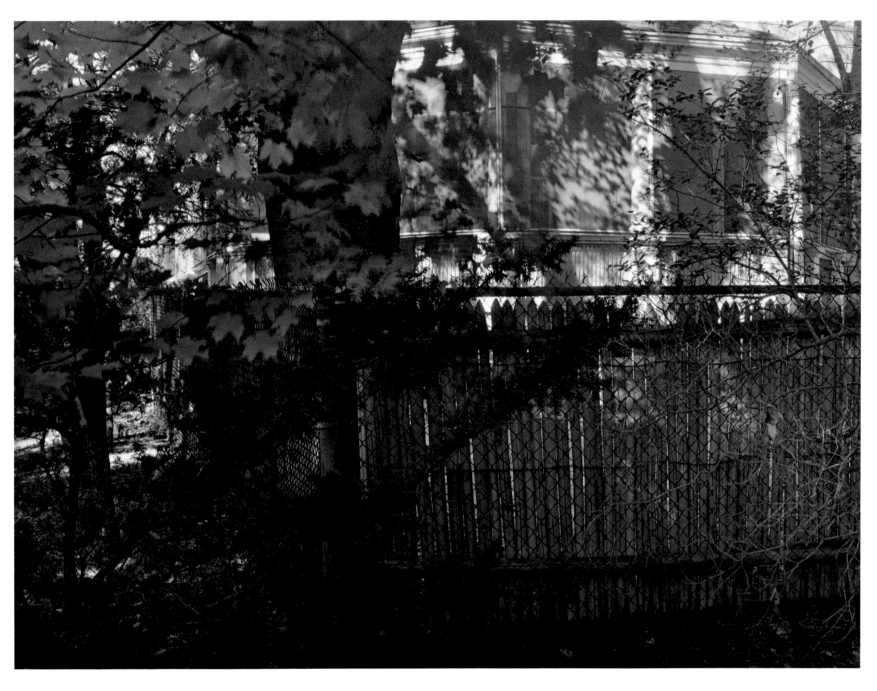

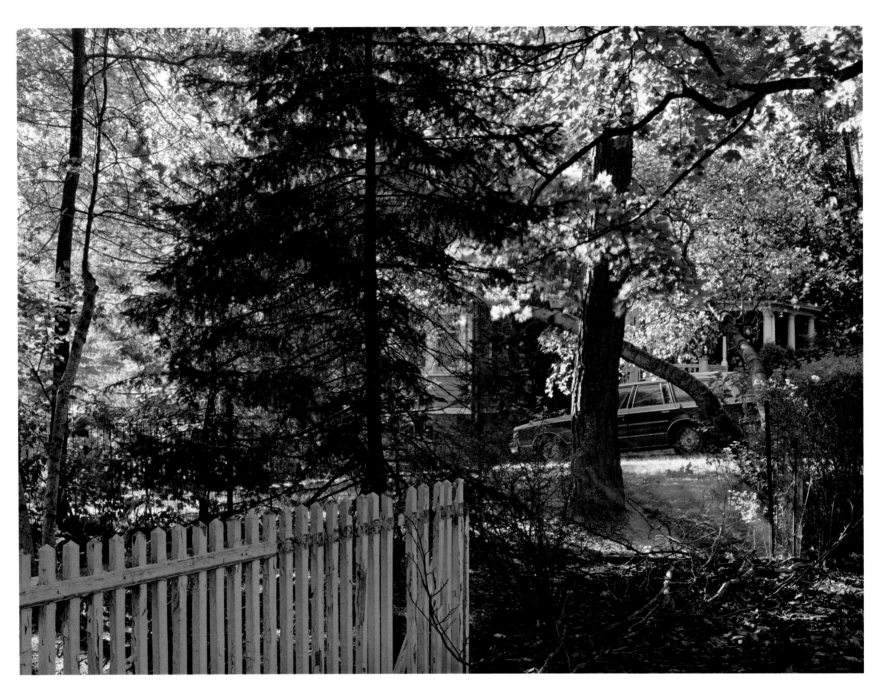

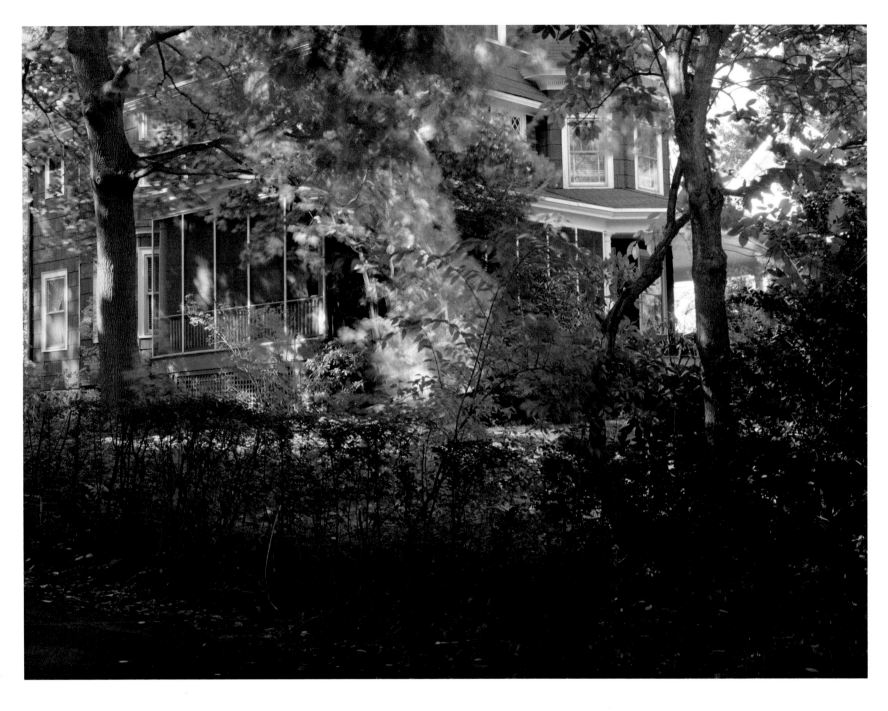

69

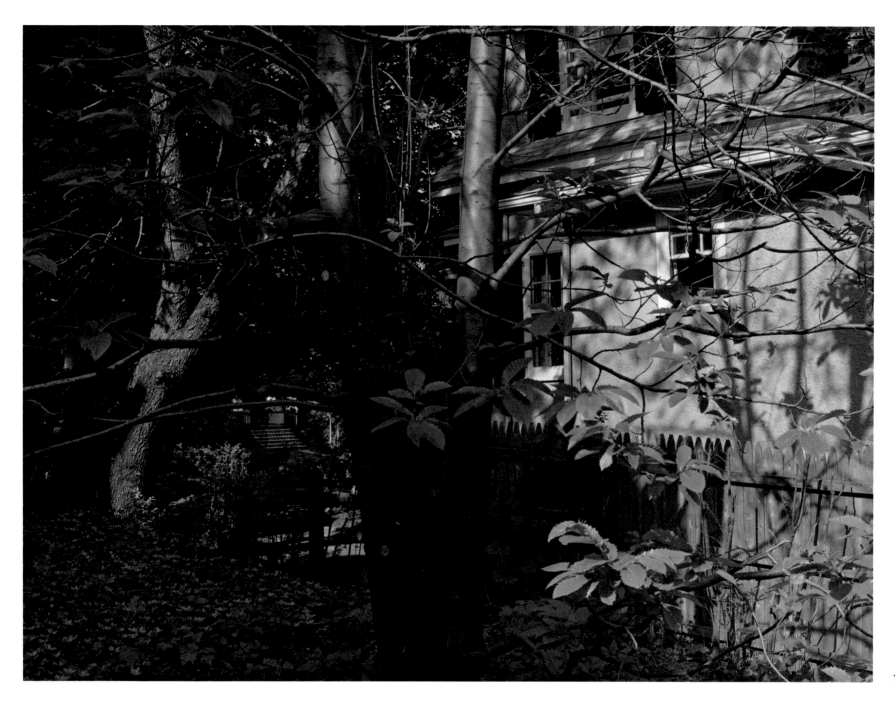

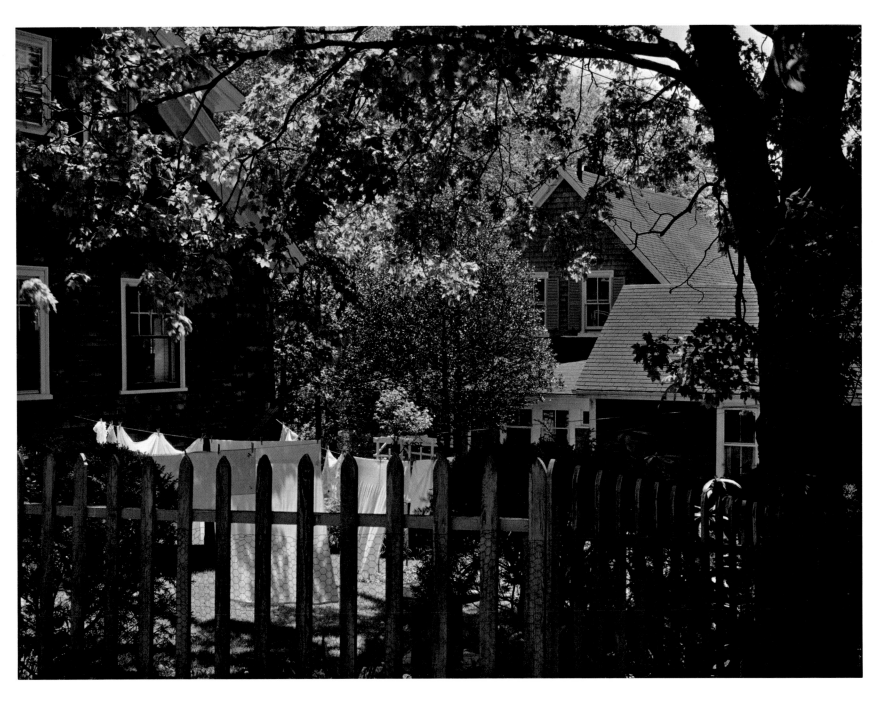

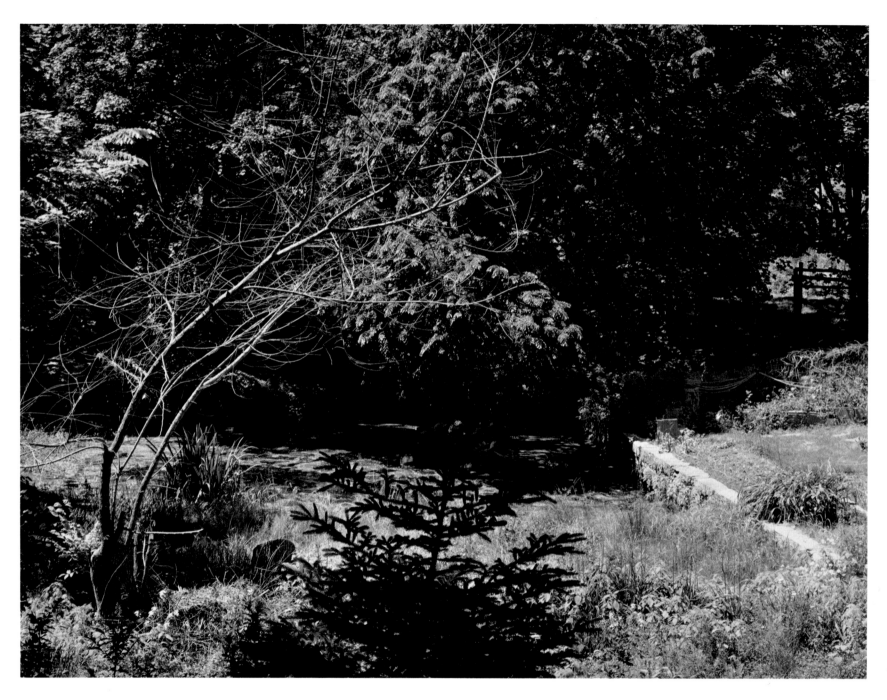

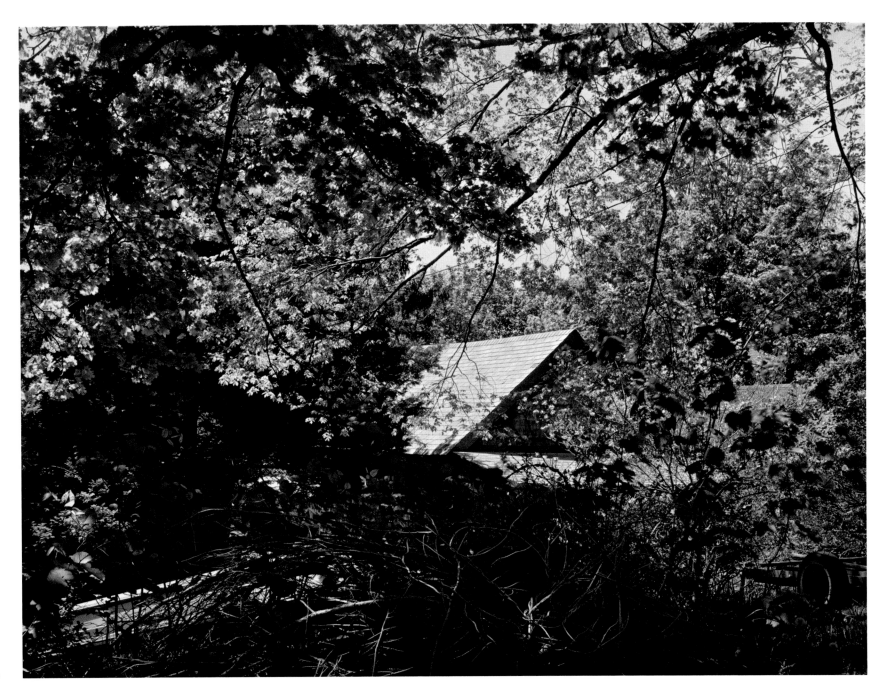

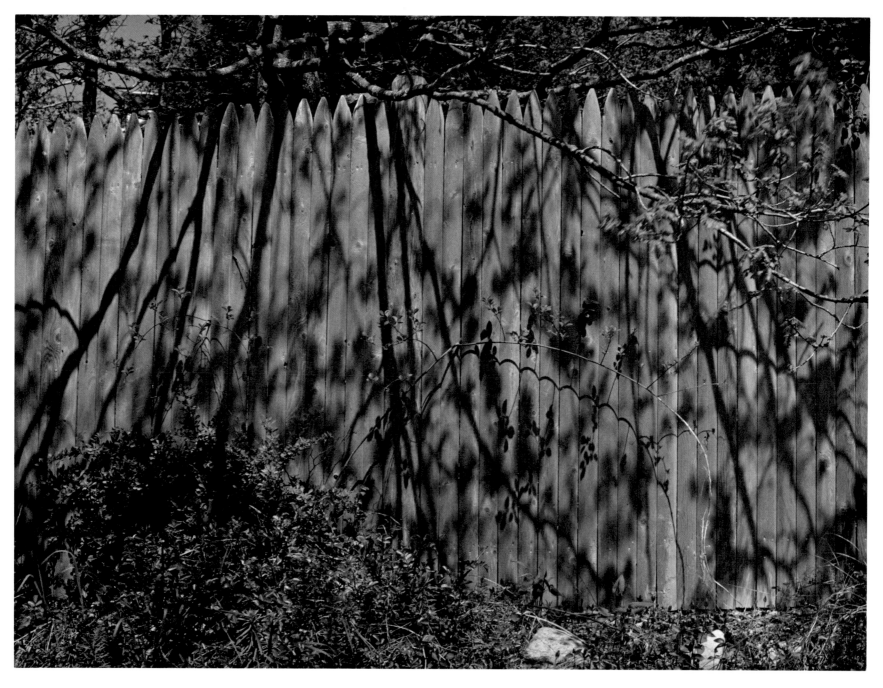

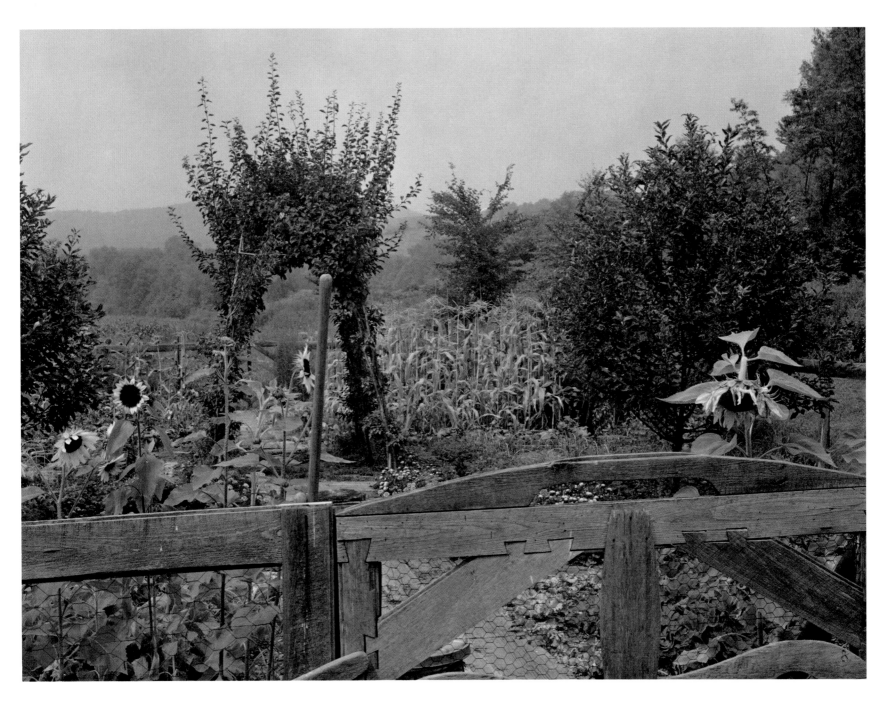

75

Let every eye negotiate for itself
and trust no agent.
—Shakespeare

Location Index

Acknowledgments

Everyone should read the late William Ivins' *Prints and Visual Communication* and John Kouwenhoven's essays and his ground-breaking book *Made in America* (republished as *The Arts in Modern American Civilization*). I am indebted to both of them for their many-sided demonstrations of the importance of looking to things for ideas and for the pleasure of their clear and vigorous prose. As I have struggled to catch out the meaning of my own work, I have often got unstuck by forging on in the spirit of Kouwenhoven's belief (and book title) that "half a truth is better than none." Neither of these men hedged their bets. I admire them.

A project like *An American Field Guide* grows out of years of work and the supporting energies of many people and organizations. A fellowship from the National Endowment for the Arts bought time to shape *Common Ground* and to make some of its images. A grant from the Wisconsin Arts Board helped in preparing the book for publication. I am grateful to William Weege and Steve Agard for at different times but in major ways making it possible for me to test to the fullest my desire to make images. My debt to the painters Jack Beal and Sondra Freckelton for friendship, shelter, and counsel continues to mount. Tom Garver, director of the Madison Art Center, has never wavered as an ally and friend through some very rough times. I am grateful for his help with *Common Ground,* for his institution's support of a traveling exhibition of the book's images, and for his expertise in wiring and climate control. For helping to keep my darkroom together and for working in it when it was a war zone I thank David Shaw and Neil Rickman. A number of people have been of great help as I worked to clarify my thinking about photography and art, and how they relate to living. We are not necessarily in agreement, but our conversations have been invaluable to me. They are Tom Bamberger, Fina Bathrick, Jack Beal, William Crawford, Sondra Freckelton, Jan Zita Grover, Larry R. Larson, and Dana Van Horn.

Alex and Caroline Castro of the Hollow Press are responsible for the page-to-page relationships of the images in *Common Ground* and made valuable suggestions on sequencing. I look forward to working with them again.

My thanks to Christopher Harris for designing *Common Ground* so that its

ideas stay in motion yet do not fly apart. He appears to be as calm as the eye of a storm, but his work is full of surprise.

In a class by themselves, for the courage of their eyes, are Jane Livingston and Frances Fralin of the Corcoran Gallery of Art and Judy Metro of Yale University Press. They are the real thing. I have never known better people to work with.

My father taught me to write, and having read and advised on "Why a Camera?" now says he should have compared my teenage gaze not to a trout's, but to a piranha's. My mother taught me faith and not to pay attention to everything my father said. I am grateful to them both.

Even so, and everyone on these pages understands, there would be nothing without Dorothy, my companion and wife, and Ruth, my daughter. This book took shape as we met, fell in love, and became a family.

A Note on Craft Imade all the photographs in *Common Ground* with a Bronica ETR, a medium-format camera. The lens was a 75 mm Zenzanon set at F22 with shutter speeds which varied from 1/2 to 1/15 of a second. The camera was on a tripod.

All of my negatives are on Ilford FP4, a film which I rate at 25 ASA, use with a K2 yellow filter, and develop in a 1 : 1 solution of D–76. I work with a stripped and modified zone-system approach to exposure that permits me to play on the gray scale like a musician who improvises. The performance is in the negative, and the print is basically a straight record of that event.

The prints for *Common Ground* are on Ilford Ilfobrom, a fiber-base paper that I have found to be highly responsive. I do very little burning or dodging, but I do nudge a print's tone while it is developing. I use two-bath development (Selectol Soft and Bromophen) in which I vary dilutions and processing time to give a tonal balance that most accurately renders the experience I tried to put in the negative. The original image size is 12 × 16 on 16 × 20 paper, archivally processed and selenium toned. My enlarger is a Durst L–1200, a pricey machine whose virtues are its stability and diffusion light source.